RIDING SHOTGUN WITH NORMAN WALLACE

4-19-20

For Al and Kathy—
It's about time for an Arizona
road trip!
With best Wishes,

Bill

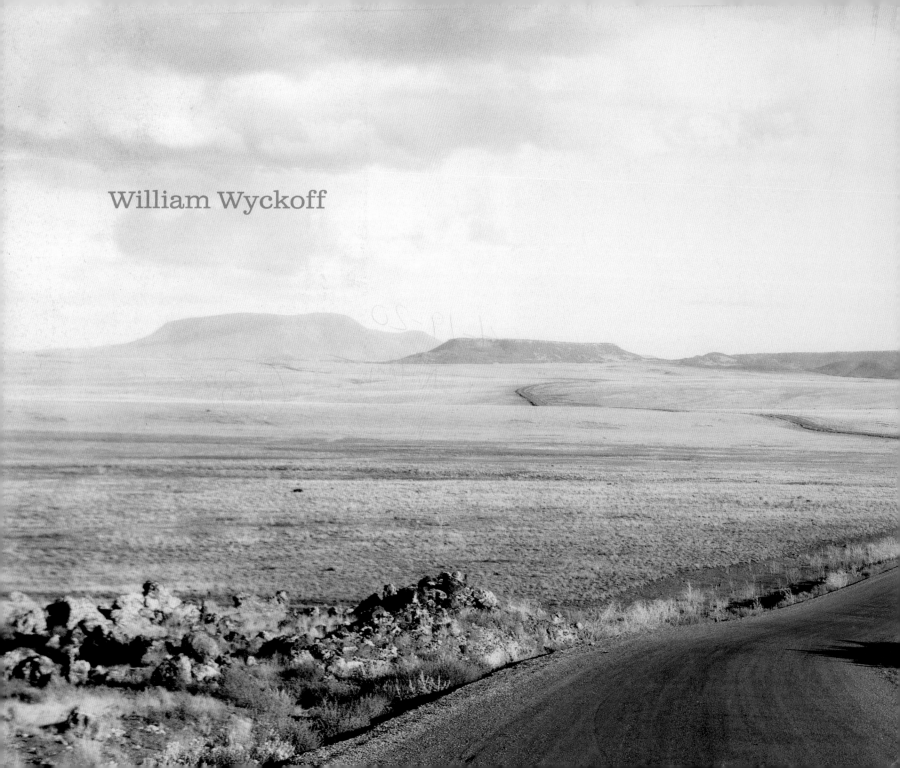

William Wyckoff

RIDING SHOTGUN

WITH NORMAN WALLACE

Rephotographing the Arizona Landscape

University of New Mexico Press Albuquerque

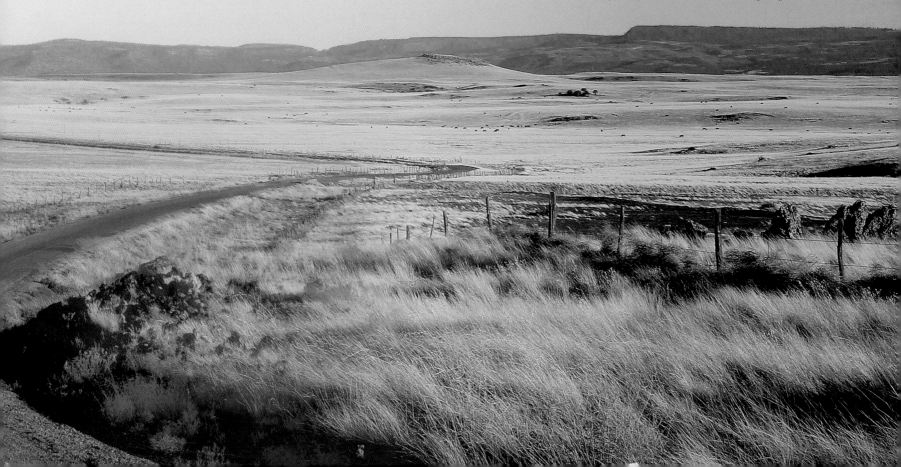

Library of Congress Cataloging-in-Publication Data

Names: Wyckoff, William, author.

Title: Riding shotgun with Norman Wallace: rephotographing
 the Arizona landscape / William Wyckoff.

Description: Albuquerque: University of New Mexico, 2020.
 Includes bibliographical references and index.

Identifiers: LCCN 2019037143 (print)
 LCCN 2019037144 (e-book)
 ISBN 9780826361417 (paperback)
 ISBN 9780826361424 (e-book)

Subjects: LCSH: Arizona—History—20th century—Pictorial
 works. | Wallace, Norman Grant, 1895–1983. | Landscape
 photography—Arizona. | Repeat photography—Arizona. |
 Highway engineers—Arizona—Biography. | Photographers—
 Arizona—Biography. | Arizona—Biography.

Classification: LCC F812. W93 2020 (print) | LCC F812 (e-book) |
 DDC 979.1/053092 [B]—dc23

LC record available at https://lccn.loc.gov/2019037143

LC e-book record available at https://lccn.loc.gov/2019037144

The Ivan Doig Center for the Study of the Lands and Peoples
of the North American West generously provided funding
to support publication of this book.

Front cover photographs: *Ascending Sitgreaves Pass* (1933)
 by Norman Wallace and *Ascending Sitgreaves Pass* (2016)
 by the author.

Back cover photographs: *View Down Congress Street* (1927)
 by Norman Wallace and *View Down Congress Street* (2016)
 by the author.

Designed by Mindy Basinger Hill

Composed in 10/15 Arno Pro, Acumin Pro, Clarendon Wide,
 and Clarendon Wide Stencil

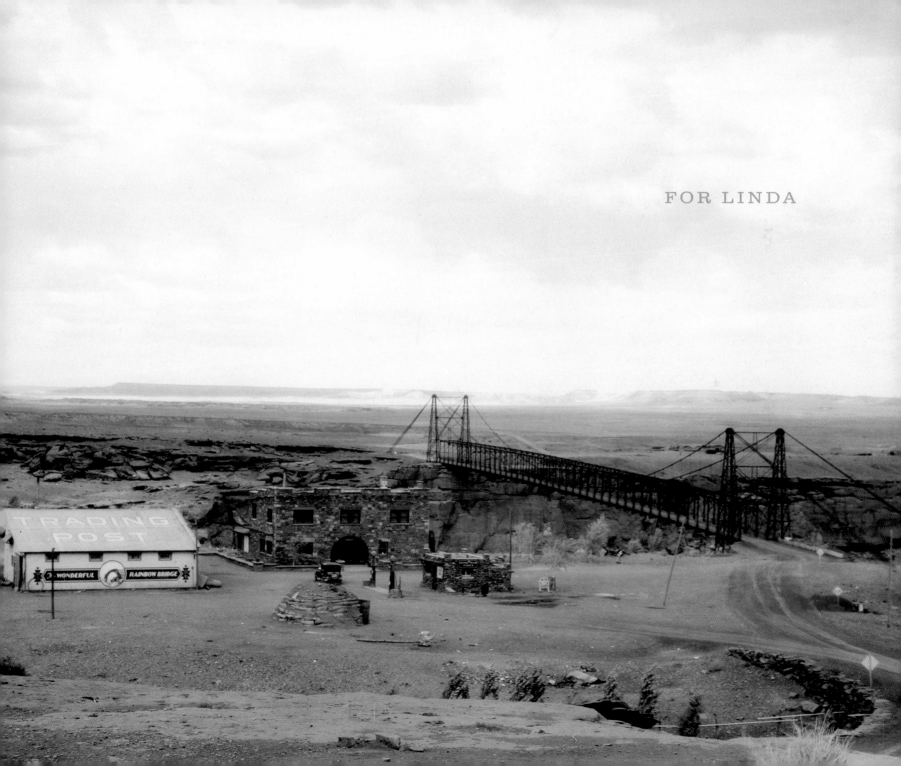

FOR LINDA

CONTENTS

Preface
ix

Acknowledgments
xiii

Map of
Photograph
Locations
xv

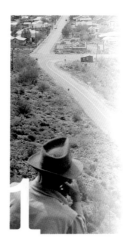

Meeting
Norman Wallace

1

Nature's
Palette

21

Monuments
to History

41

Mining's
Mark

59

5

Small
Towns
79

6

Mother
Road
99

7

Urban
Arizona
123

8

Far
Corners
141

Epilogue
165

Bibliographic
Essay
167

Index
173

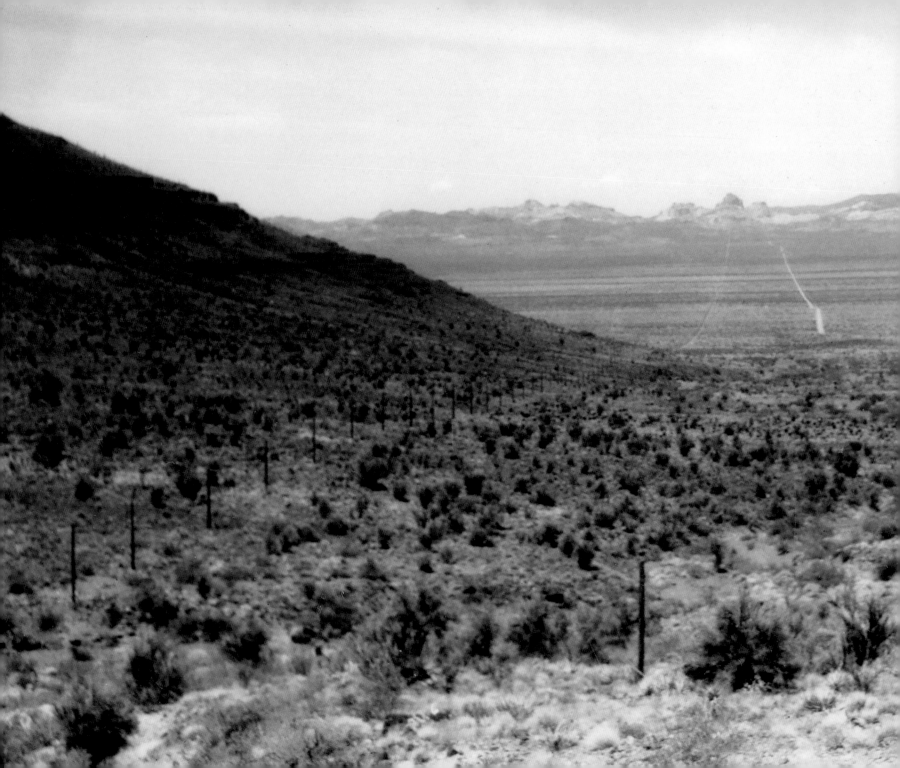

Norman Grant Wallace and his photographs of Arizona became a part of my life many years ago as I casually enjoyed the work he published in *Arizona Highways*, the state's booster magazine. Gradually I came to know his name, the characteristic views that defined his work, and the ways he framed Arizona's landscapes. Several years ago I waded into his photo archives at the Arizona Historical Society in Tucson. Much of that collection was produced during his long career as a transit man and location engineer for the Highway Department.

Our friendship crystalized when I found images of Wallace at work along with an old cassette recording—an oral history—of his life recollections. Just listening to his voice brought me closer to him, hearing the gravelly twang of a midwestern boy who relocated to Arizona early in life. It was a voice seasoned with vivid memories of what he had seen and experienced across the Arizona landscape, and it carried a real reverence for that landscape's value and

beauty. Listening to him, you understood why photography mattered so much to the way he remembered and treasured the world.

Best of all, his pile of well-preserved photo log books opened my eyes to the pace and texture of his life. In them he recorded in great detail the natural and human subjects he encountered and photographed on any given day: morning cacti, time at work on a highway-construction project, a Main Street view of a nearby town, an afternoon thunderhead, a sunset amid saguaros . . . And so it went. Days, months, years, and decades of making pictures of the Arizona landscape, a vast, rambling accumulation of highways, places, and scenery.

This awakening to Norman as a human being paralleled the evolution of this project. When I initially thought about rephotographing Arizona, I was simply interested in obtaining a set of evocative historical views—some urban, some more natural—that would form the raw material for what I could repeat and then

ponder. I wanted photographs of good technical quality, of places I could find, and of subjects that represented the variety one encounters in Arizona.

As I got to know Norman in the archives, I saw a larger story taking shape, the story of the man behind the lens who was both recording and participating in Arizona's twentieth-century transformation. But the deal was really sealed as I started my own field excursions with Wallace's photographs in hand. I saw the world—a bit at least—through his eyes as I retraced his steps up a rocky slope and included, or excluded, a particular building or a hillside in my viewfinder. That process was in some ways a bit haunting because our lives never exactly overlapped, but it nevertheless brought me closer to Norman's view of the world. It was a view that reflected his time, not my own, but it also revealed an eye for landscape that possessed an enduring power to capture and evoke Arizona's diverse place identity.

Seven galleries of photographs introduce you to Wallace's view of Arizona as he captured it between 1912 and 1950. My accompanying images reveal what I found between 2016 and 2018, and together they form a record of the relationship I built with Norman and his work. The varied settings and stories suggest how many types of landscapes sparked his imagination and how much I discovered by following in his footsteps.

Nature's Palette

Much of Wallace's inspiration for making his Arizona images came from the state's natural environment. He seems equally charmed by Sonoran Desert cacti, the cool, green conifers around Flagstaff, or the bare red-rock country of the Vermillion Cliffs. He loved Arizona spaces, the way the sky, the clouds, and the far horizon opened up one's world, putting seemingly ordinary landscapes onto a larger visual stage.

Monuments to History

Wallace was also fascinated with the past, and his photographs often communicate a special relationship he had forged with Arizona's historical evolution. That story included Native American landscapes and ruins, the era of Spanish and Mexican influence, and the romance associated with American exploration and dominance. Norman's images suggest he might have been perfectly happy living in another century.

Mining's Mark

So much of Arizona's formative economic development—which overlapped with Norman's time there—was fashioned by mining: in the shadows of headframes, stamp mills, and industrial smelters. His photography reflects the role of the mineralized world and all the investments that flowed through it—at least for a time—in shaping Arizona's landscape and the state's relevance to the modern world. Wallace recognized that industrial imperative, and he celebrated it in his work.

Small Towns

Perhaps Norman's midwestern roots drew his eye to the Main Street view, the predictable arrangement of bank blocks, hotels, and downtown busi-

nesses in Arizona's small towns. His highway work took him to just about every community in the state. Even towns that might boast nothing more than a gas station or a general store attracted his eye. Norman knew them all, and he enjoyed photographing them from every angle.

Mother Road

Norman and US 66 grew up together, and many of his images reflect the time he spent along its length. Dozens of photographs document improvements along the route between 1932 and 1950, while others simply celebrate the scenery and open spaces Norman encountered along the fabled road. No doubt it was the road he knew best across the state, and it was one that he fun-

damentally transformed from a rough and dusty track into a modern highway.

Urban Arizona

Wallace's photographs of Arizona's cities capture many different expressions of the urban landscape. His street views record modernity's mark as paved roads and contemporary urban forms replace rawer frontier settings. We see Tucson and Phoenix rise as twentieth-century urban places, marking the arrival of metropolitan America deep in the Arizona desert.

Far Corners

Norman left few roads untraveled in his decades of wandering across the Arizona landscape. I appreciated my visits all across the state—to the

southern border with Mexico, to the northern state-line boundary with Utah, and everywhere in between. The settings for these images all became special places that Norman and I shared through the photographs we both made. I loved looking through the camera and seeing, at least in part, what Wallace saw fifty, eighty, or even one hundred years earlier.

Thanks to Norman, I will never look at Arizona in the same way I did before we met. His life, the images he made, and the experiences he recorded in his log books are now a part of my own life. My images of the state took shape under his guiding hand, and they record the fascinating story of how time unfolds in particular places. They also record the story of how Norman's life mingled vicariously with mine.

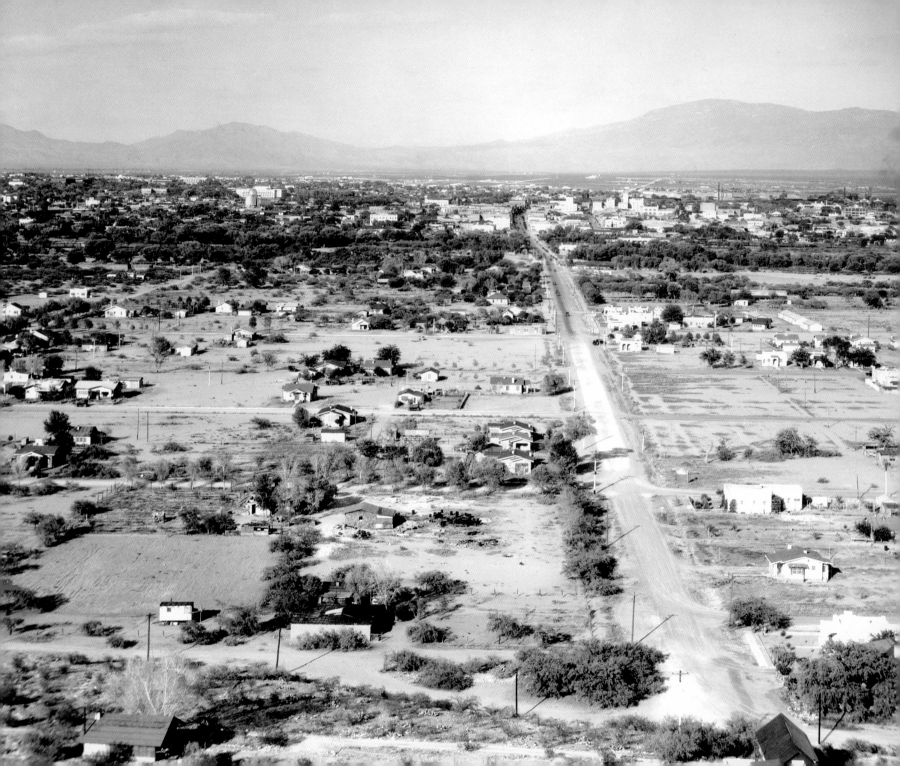

Many friends, professional colleagues, and family members helped bring Norman and me together to share our photographs in this book. Kate Fitzpatrick, Rebekah Tabah Percival, and the staff at the Arizona Historical Society (AHS; http://arizonahistoricalsociety.org) were unfailingly helpful and supportive at every stage of this project. They made enjoyable and productive the many white-gloved days I spent with Norman's images and with the rest of his well-preserved manuscript collection in Tucson. They made it possible for me to recreate Norman's world and to reproduce his wonderful photographs.

My editors, Clark Whitehorn and Sonia Dickey, were instrumental in efficiently carrying the book through to production at the University of New Mexico Press. More than that, they helped crystallize for me how the book would look, and they stressed the importance of telling my own story and how it intersected with Norman's life and the images he made. I also want to thank James Ayers and Mindy Basinger Hill at the press for their creative ideas in editing and designing the book from start to finish. In addition, Eric Sproles generously helped me in assembling the map that locates all of Norman's photo points across the state.

The publication of this book was made possible by very generous grants from the Ivan Doig Center for the Study of the Lands and Peoples of the North American West at Montana State University. I am indebted in particular to Nicol Rae, Susan Kollin, Mary Murphy, and Bob Rydell for their support of the project through the center, both for helping me to complete the research for the book and to publish the color images that appear in it. In addition, a grant from Montana State University's Center for Faculty Excellence made it possible for me to complete my repeat photo fieldwork in Arizona and to acquire digital copies of Wallace's images from the AHS. I also enjoyed the unfailing support of my friends, colleagues, and students in the Earth Sciences and History Departments.

I benefited greatly from suggestions and

ACKNOWLEDGMENTS

shared comments made in a special session on repeat photography that I organized at the annual meeting of the American Association of Geographers in New Orleans in 2018. In particular, I want to thank my fellow presenters, Bill Wetherholt, Matt Fockler, Yolonda Youngs, and Mike Amundson.

My taste for vernacular landscapes and what they might mean was surely shaped by my many years of friendship with Don Meinig, Bill Cronon, Peirce Lewis, Fraser Hart, Wilbur Zelinsky, Lary Dilsaver, Michael Conzen, Paul Starrs, Dan Arreola, Jack Wright, Terry Young, Rich Schein, and Don Mitchell. I learned so much from each of you.

More particularly, many people across Arizona helped assemble pieces of my puzzle as I wandered from place to place, answering dozens of my questions about history, geography, people, particular buildings, and much more. I wish to thank helpful folks at the US Border Patrol; the caretaker at Ruby; Terri Urrea in Clifton; Dan Jacobs in Congress Junction; Chris, Lisa, and Kirk in quiet Ash Fork; Carl Colson in Cameron; Tony, Chris, and Kelly in Hillside; David Romo in Prescott; the helpful NPS staff at Tumacácori, Canyon de Chelly, Wupatki, and Pipe Spring National Monuments; the especially creative and well-informed bartenders at the Monte Vista Hotel in Flagstaff and at the Copper Queen Hotel in Bisbee; Janeen Trevillyan of the Sedona Historical Society; Clair Thomas in Show Low; Lawson Nielsen in St. Johns; the Bundy Family in Wolf Hole; and the guys at Randy's Downtown Garage in Flagstaff.

Most importantly, thanks go to my family for their enduring support, love, and encouragement. My folks get the credit for first taking me to Arizona more than fifty years ago. Over the years my children, Tom and Katie, endured additional journeys to the Grand Canyon, Canyon de Chelly, and many other famous and more obscure western places. Special thanks go to my wife, Linda, for her proofreading, patience, good cheer, and ongoing enthusiasm for the project.

Finally, I want to thank Norman Wallace for being the curious, creative fellow that he was and for having the energy and persistence to produce the photographic record of Arizona that he did. I thoroughly enjoyed his vicarious company as I retraced his steps, and I learned so much from where he stood, whether it was on a busy city street or on a lonely saguaro-studded slope.

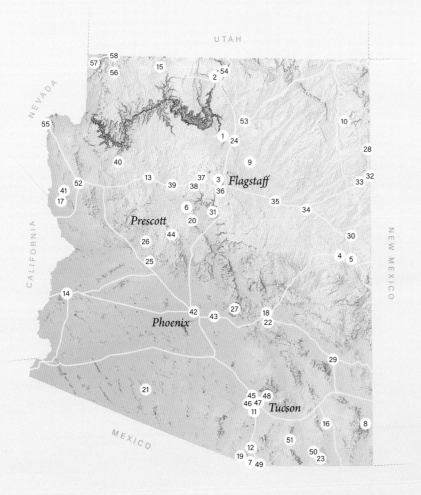

MAP OF PHOTOGRAPH LOCATIONS

1 Along the Navahopi Trail

2 Vermillion Cliffs

3 San Francisco Peaks

4 Montoso Summit

5 West of Springerville

6 Along the Verde Valley

7 Péna Blanca Spring
and Castle Rock

8 Backside of the Chiricahuas

9 Reimagining Wukoki

10 Canyon de Chelly

11 Mission San Xavier del Bac

12 Tumacácori

13 Chino Wash

14 Ode to Hi Jolly

15 Making History
at Pipe Springs

16 Pearce Commonwealth Mine

17 Tom Reed Gold Mine

18 Miami Smelter

19 Ruby's Montana Mine

20 Jerome

21 Ajo

22 Globe's Broad Street

23 Bisbee

24 Cameron

25 Quiet Day in
Congress Junction

26 Downtown Hillside

27 Exploring Tortilla Flat

28 Fort Defiance

29 Safford's Main Street

30 St. Johns

31 Sedona at the Crossroads

32 State Line

33 Near Lupton

34 Entering Holbrook

35 Downtown Winslow

36 Heading West
through Flagstaff

37 Concrete Byway

38 Tracking the Interstate

39 Disappearing Ash Fork

40 Cruising Near Peach Springs

41 Ascending Sitgreaves Pass

42 Central Avenue

43 Mesa's Buckhorn Baths

44 Prescott's Gurley Street

45 Depot

46 View Down Congress Street

47 Stone Avenue Underpass

48 Approach to Sabino Canyon

49 Border at Nogales

50 North of Bisbee

51 Rain Valley Ranch

52 Coyote Pass

53 Tuba City Trading Post

54 Navajo Bridge

55 Vanishing Lake Mead

56 Wolf Hole

57 The Virgin at Littlefield

58 Heading for Utah

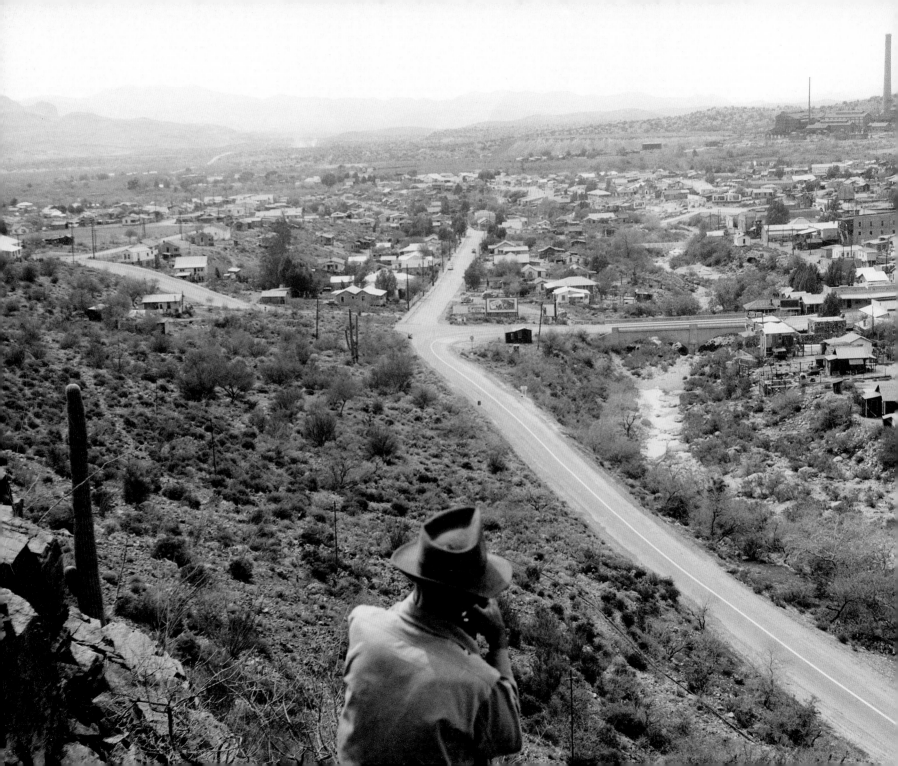

1

MEETING
NORMAN WALLACE

Follow his eye. Let him raise the camera and frame a scene. The town below, the smelter stack beyond, and the road running at an angle across the bottom of the view. Hold steady, make a slight adjustment, catch a touch more sky with the horizon gently dipping away from the stack. Take a photograph. Maybe another. The man facing away from us, Norman Wallace, camera in hand, repeated that simple act thousands of times across Arizona between 1906—when he arrived in the territory—and his death in 1983.

Decades later, my adventures in Arizona became wedded to Wallace's. My perfect day became standing where he stood and peering into my Canon viewfinder, often perched on unstable slopes and grabbing at saguaros for support, then watching the smokestack align, altering the zoom just a touch to catch the same sweep of hills on the horizon, and getting a distant roof—its tiny trapezoidal shape—to sit just above the road in my view. I knew what that simple positional truth proclaimed: that I stood within a foot or two of where Norman

had stood seventy-eight years earlier; that in a small but visceral way I shared a part of his day, a view, an idea for a picture of this place, that same alignment of bushes, highway, streets, and sky.

I found that repeat photography (the act of retaking an image from the same vantage and under as similar conditions as possible at a later point in time) taught me so much about how the landscape of Arizona had changed between Norman's time and mine. Sometimes the changes were predictable, but often there would

opposite Norman Wallace on the hills above Superior, Arizona, undated. Photo reproduced courtesy of the Arizona Historical Society (hereafter AHS), PC180, Folder 256, #A.

be a curve ball—a shack on Tucson's west side that still stood ninety years later or a tree in a remote valley near Nogales that had stubbornly survived to stare me down, just as it did Norman. In addition to understanding how landscapes change—or sometimes don't—I also came to know Norman better and better, at least the part of himself he left in his photographs. Like all of us he was a complicated human being, rich with contradictions—a man of his time, a man more of images than words, a man who seamlessly mingled his work life (he was a civil engineer who surveyed rail lines and highways) with his artistic life. I found that I enjoyed exploring what he enjoyed exploring—Arizona's amazingly rugged terrain; its plethora of wondrous, exotic vegetation; the visual presence of geological time in colored, layered rock; the spare beauty embodied in Native-crafted stone walls; small towns that drew his gaze; bustling urban boulevards in Tucson and Phoenix; or the linear, engineered aesthetics of highways laid across the luminous Arizona landscape.

This book visually shares my travels with Norman—the delight of riding along with him down some dusty byway for miles, scampering up a hill that showed promise as I peered at one of his old photographs, pacing, cursing, watching how slopes, or maybe a fence or a human structure, finally look back at me, finding the same flat, rusty-red rock he had seen at this precise spot decades earlier. I wish Norman could have known how much pleasure he gave me in moments where I instantaneously learned something—both about him and about the landscape we momentarily shared. The galleries that follow offer only a fraction of Norman's take on Arizona, but they represent well the sweetly parochial nature of his own character, the tireless energy that compelled him to make pictures of a land he dearly loved, and also the considerable talent he developed as a photographer.

Hopefully you can share the same surprise and fascination I found in revisiting these places and draw your own conclusions about what these paired experiences mean. More than anything, let these visual parables draw you into the landscapes of Arizona, into the landscapes that fascinated both Norman and me, and let them lead you into wonder at how that world—in Arizona and beyond—became at once so beautiful, so confounding, so ephemeral, and so enduring. Norman learned all those lessons. They are in his photographs, and they are in the ones I created later, following in his footsteps.

Norman Wallace and His Visual Legacy

Norman Wallace was making images of Arizona with a simple Kodak Box camera almost as soon as he arrived in the territory in 1906.[1] A native son of Cincinnati, Wallace left an engineering program at Ohio State University in 1905 during his junior year to get some practical surveying experience out West. He never went back. After road-construction work in Yellowstone National Park, he knocked around eastern Oregon, working that winter as a draftsman on a rail-line-construction crew. The following year he remained in the West, and he was attracted to the warmer climes of Tucson. The photo hobby was a natural for Norman: his father—an accountant by profession—had been an amateur photographer in Ohio, and as Norman got to know the Southwest, he readily picked up the habit. Later in life his wife, Henrietta, recalled that Norman "always had a camera wherever he traveled" and that "he was married to his cameras before he was married to me." And, she admitted, much of that romance continued even after Norman married.[2]

Wallace lived and breathed photography. He went everywhere with his cameras, keen to capture everything from wilderness scenery to city streets. He graduated from his simple early Kodak, and over the years he owned an assortment of more sophisticated equipment. He took thousands of images with a large-format 8 × 10 bellows camera, another 5 × 7 Graflex camera, a medium-format Zeiss Ikonta camera, and a small Ranca miniature camera, which he used for making color exposures beginning in the late 1930s.

Always the engineer and surveyor, the location and circumstances of each exposure—on any of his jobs or life adventures—were carefully recorded in his log books, and he would annotate these in later years with additional details about the image and how the print version turned out.[3] Occasionally he would add a bold star next to his best photos, or a wistful "bad luck" or "blurred" to prints that didn't live up to his expectations. For me, reading these detailed records (I scanned more than 1,400 pages) became a kind of running narrative of his own creative world, a journal of visual encounters that was episodically punctuated with the briefest mention of life's larger events: in November 1932 he scribbles, "Election Day, Hoover defeated Tuesday"; two years later he allows, "Married Dec. 27–1934." It was clear what mattered most.

As Wallace spoke to me through his log books about his daily work and image-making schedule, I saw how his professional and artistic lives were fused together. His thousands of detailed notations made it clear that his decades with the Highway Department offered extraordinary opportunities to marry his love of photography with his talent for locating, surveying, and building highways. As his carefully tabulated log books showed me, his "state" pictures were constantly interwoven—even on a single day—with his "art" pictures. He might photograph a road-grading project near Tucson in the morning, do a few in-depth studies of cacti as he ate lunch, and end his day with a panorama of San Xavier del Bac Mission south of town.

The log books revealed to me several special dimensions of Wallace's life. First, while he devoted many pages to construction-related projects and images, Wallace clearly relished a good road trip, purely for pleasure. He would list each day's camping place, offer a comment or two on the weather, and give details about the scenery he was capturing on film. He liked roughing it: one night, miles north of Cameron

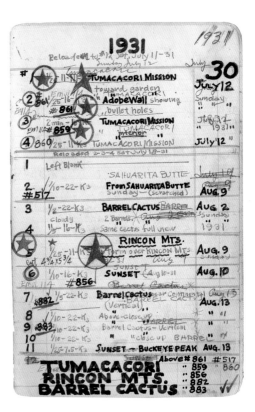

Sample page from Wallace's photo log books, Log Book 1, 1931. AHS, PC180, Folder 377.

on the Navajo Reservation, he contentedly jotted down that he was spending the night at the "Hotel de Wallace" beneath the stars. He also dashed in little comments that reflected his love of history. He would take images "along Beale's route" (an expedition from the 1850s) across northern Arizona, or he would enthusiastically note that he was exploring where Coronado may have camped four hundred years earlier. Norman also revealed his weakness for disasters: he could never pass up an automobile wreck, and he took many pictures of floods, washed-out roads, dust storms, and snow-drifted highways. This daily dose of entries would never be as good as sitting down with him for a chat, but it revealed in honest, straightforward ways some of the unsung details of his life.

Norman's early career in the West focused on railroad surveying and drafting, important tasks at a time when the region was changing rapidly, when major trunk lines were being improved and relocated, and when many miles of new track were being built to mining districts and other growing settlements. During much of the time between 1906 and 1932, Wallace was based in Tucson, but he took many jobs that sent him to the far corners of the region. He worked on a variety of branch lines in southern and eastern Arizona, California, and southern Oregon. He also spent many months in the rough, almost lawless country of mountainous northern Mexico while working for a branch of the Southern Pacific; there he picked up a good deal of Spanish and learned to live and work mostly outdoors and under challenging conditions. Young Wallace took to it all in stride. He worked hard and found he loved the comradery of the survey gangs and their relative independence from the corporate boardroom. He loved life outdoors and the regional landscapes that were both a challenge to his surveyor's eye and a constant lure for his photographer's gaze.

Between jobs—he often spent weeks, even months between steady work—Norman took long and meandering "picture trips," often with a camping buddy or two. He would take dozens of exposures, then bring back the film to be developed in his little Tucson dark room.

2 Asses

Two asses (Norman Wallace and friend) in Mexico, circa 1907. AHS, PC180, Folder 208, #H.

On one ambitious adventure in the summer of 1931, after being laid off by the Southern Pacific, Wallace and his good friend Jim Blacksill gassed up Norman's 1928 Buick and drove north to Grand Canyon, east across the Hopi and Navajo country, and then south into eastern Arizona's White Mountains. They covered over 1,500 miles in two weeks—much of it on primitive dirt roads—and Wallace had his camera ready everywhere he went.[4]

In 1932 Wallace's career took a major turn that shaped the rest of his professional life and thrust him into a more prominent position in both transforming and recording the Arizona landscape he had grown to love. Laid off once again by the Southern Pacific, Norman was casting about for a job. It was Depression-era Arizona, and the region's economy was suffering along with the rest of the country. Tom O'Connell, a friend of Wallace's, saved the day. He knew about an opening for highway transit men and surveyors up in northern Arizona, near Flagstaff. Soon Wallace was working on US 66 for the state's Highway Department, beginning a second career that lasted until 1955. Wallace loved the work, and his new northern Arizona home gave him an opportunity to explore and photograph a very different part of the state. Every

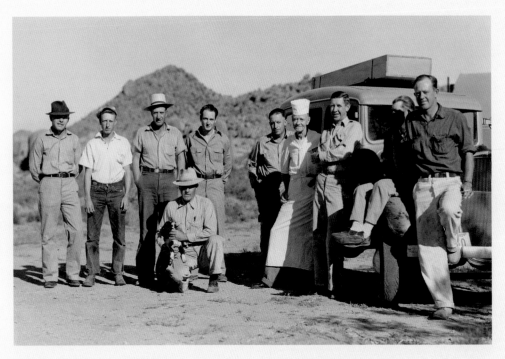

Norman Wallace (kneeling with dog) and his Arizona Highway Department location survey party, south of Yucca, 1940. AHS, PC180, Folder 210, #0107.

day off (usually Sunday) that weather permitted, even on Thanksgiving, Norman ventured out on day trips that took him to Oak Creek Canyon, the Painted Desert, Wupatki National Monument, the Grand Canyon, the San Francisco Peaks, and more.

It was a formative period for the state and its highway system. Wallace did well in the agency

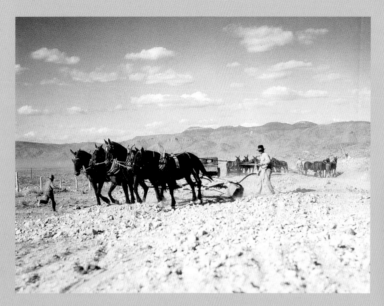

Road construction along US 66, near Peach Springs, 1933. AHS, PC180, Folder 144, #2013.

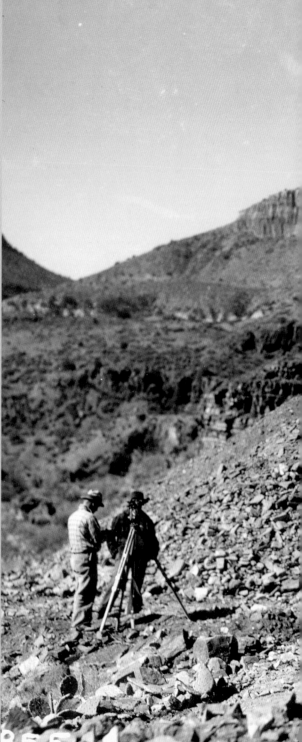

as it grew: within two years he was promoted to the position of location engineer, in which he was responsible for actually locating the precise routes of new roads, often through incredibly rugged terrain. In 1943 he was further promoted to be the Highway Department's chief location engineer for the state, a position he held until his retirement. Wallace's wife, Henrietta, whom he married in 1934, estimated that Norman lived in thirty-six different Arizona localities during his Highway Department career, typically for a period of anywhere from six weeks to ten months. It took Wallace from Bisbee near the Mexico border to Kingman just down the road from Boulder Dam.

In each place, Wallace worked on a different highway project, typically "in charge of a gang" of nine or ten men. The key objective of the crew—a motley mix of transit men, chain men, rod men, levelers, brush cutters,

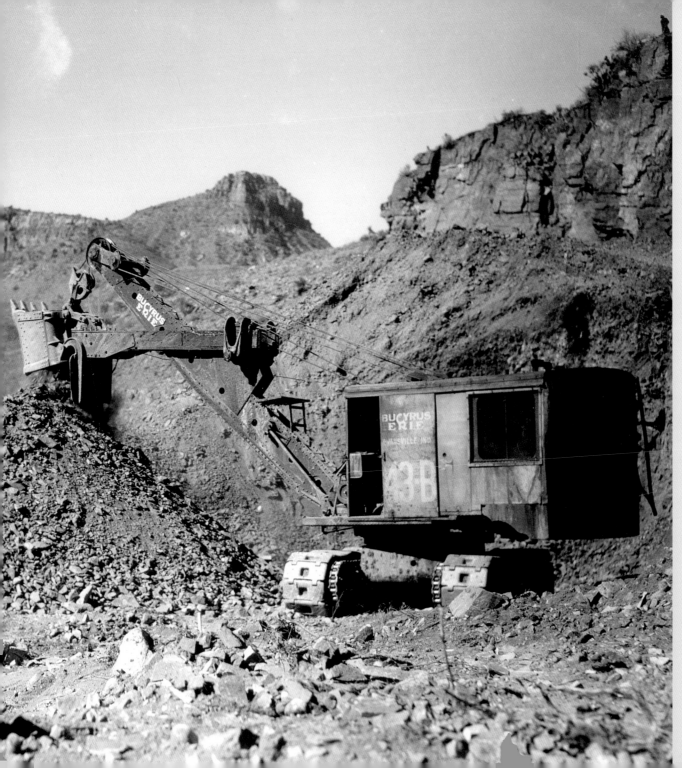

Road construction
along US 60, Salt River
Canyon, 1933. AHS,
PC180, Folder 28, #620.

a truck driver, a cook, and sometimes a dog—was simple: find the best route for the planned highway, confirm it on foot, and then carefully stake it for construction crews, who would grade and build the road. Wallace wrote about the process of "staking" a new route: "This said stake punching thus becomes the focal point for nine tenths of the cussing it takes and 100 percent of the gray matter used to get a highway to the point where it will be found practicable. Herein lies the tale of the locating party."[5] When Wallace wasn't locating roads he was helping to build them, often being called in to relocate an older, perhaps dangerous portion of highway or figuring out the best locations for new bridges and tunnels when particularly tough roads challenged ordinary engineers. He participated in a process that included a dizzying variety of equipment and technology. He used teams of horses to level portions of US 66 near Peach Springs, but he also watched as state-of-the-art Bucyrus Erie earth-moving equipment cleared the way for the new road between Globe and Show Low.

Wallace's photo "hobby" did not go unnoticed by his superiors. Soon his images, usually provided free of charge, began appearing in Highway Department reports and publications, most notably in their monthly magazine, *Arizona Highways*. Originally an insider's technical journal that highlighted the agency's engineering accomplishments, *Arizona Highways*, with Wallace's help, became a hugely popular, nationally known, mass-circulation magazine that boosted Arizona's prospects for tourism and retirement, celebrated its scenery, and promoted its amazing landscapes to an American audience hungry to know more about the exotic Southwest. Wallace published dozens of his images in the magazine, including the one used for its first color cover (a photo of Oak Creek Canyon) in 1938. Wallace also wrote many promotional stories for the magazine, focusing on the state's history and on the travel potential along many of the state's major highways (US 66, US 89, US 60, etc.). Here was one of the state's key highway engineers literally building its transportation system and also promoting its potential as a place to visit, play, and retire.

But Wallace's real passions were photography and highway construction, not promotion. While his published photographs pleased him (he even took a cover image for *Arizona Highways* near the Grand Canyon on his honeymoon), life's best pleasures came from building a safe, speedy, and elegantly designed highway and then photographing all of the fascinating places it passed through. Both required a good eye for landscape. Wallace could scan a challenging panorama of canyons, hillsides, and peaks north of Phoenix and see in his mind's eye where a highway might go. That was a rare and valued talent for a civil engineer. Wallace could take that same sensibility for landscape and find creative ways to photograph small-town Main Streets, saguaro cacti, or the red mesas of the Navajo Reservation. And it was not a casual affair, taking a picture. Henrietta recalled Norman's fussy, careful, and precise approach to photography: she remembered him saying, "When I take a picture, I know what I'm doing. Don't say a word." She quickly learned to give him his space and let him be, whether they were along a highway or on the edge of the Grand Canyon.

So—apart from work-related images of grading crews and bridge builders—what drew Wallace's eye most powerfully to the Arizona landscape? What were his motivations for making the pictures he did? As the topics for the galleries in this book suggest, Wallace had amazingly eclectic tastes in landscape, but in many ways the

subjects he chose to photograph reflected the aesthetics and interests of his time. He grew up in an era when photography increasingly became integrated into everyday life in America, when it became an important part of defining family memories, places, and regional character and also a growing part of advertising, tourism promotion, and mass consumer culture.

Indeed, Wallace was part of a large fraternity of image makers—both amateur and professional—who had grown up with the West and had carefully recorded its settlement and evolution.[6] Within Arizona itself Wallace's work as a photographer—the subjects he chose and how he framed them on film—built on well-established conventions established during the territorial period. Dozens of pioneer photographers roamed the region in the late nineteenth century; some were itinerant travelers making commercial stereo view cards or post cards for sale, while others set up shop in various Arizona towns and became important businessmen in the community.[7] For example, several decades before Wallace's arrival, George Rothrock was busily recording Arizona cacti, pioneer settlements, historical sites, and Native Americans across the territory. Rothrock also operated a commercial photography business in Phoenix. Similarly, Willis Haynes set up shop in Tucson in the 1880s and 1890s, and Camillus Fly recorded Tombstone's exciting territorial days during the same era. Like Wallace, these image makers were drawn to Arizona's dramatic natural fundament and its fascinating cultural landscapes.

Unlike Wallace—who rarely made money with his images—many Arizonans made a living through commercial photography in the early and mid-twentieth century. While Norman occasionally dabbled in selling post cards of Arizona scenery and towns, his small basement business paled in comparison to that of Burton and Josephine Frasher, who roamed the state (and all of the Southwest) between 1925 and 1950.[8] Frasher Fotos sold millions of Arizona post cards, framing their scenes of the Grand Canyon or of downtown Phoenix in conventional ways that surely paralleled Wallace's own photographic eye. Similarly, a more recent generation of Arizona photographers—including Josef Muench, Darwin Van Campen, Tad Nichols, Allen Dutton, and Mark Klett—built on the same well-established traditions of visual representation that shaped Wallace's gaze.[9]

While Wallace was no Edward Weston or Ansel Adams in terms of the sheer scale and technical quality of his artistic work, Norman's photographs remain a remarkable chapter in Arizona's image-making history. Wallace worked in the state during an especially transformative era of landscape change. Furthermore, his own life experiences—working for both the railroad industry and the Highway Department—made him an active participant in that process. The fact that he lived in dozens of Arizona places meant he got to know the state especially well. And his passion for precision along with his careful engineer's eye for subject and composition give his images a particular crispness, a clean, linear quality that readily invites the viewer into the places he photographed. Wallace's straightforward views—often taken while he was on the job or on the road—reveal an everyday, vernacular portrait of the Arizona landscape.

I found the best way to explore Norman's mind when it came to how he saw and photographed the world was to look at how he filed images in his own archive and how he ultimately organized his collection for donating it to other institutions. As his log books and filing systems suggest, Norman's pictures reflected what he valued most in the world, and these topics guided my decisions about how to rephotograph and organize Wallace's work. First and foremost—and this undoubtedly wedded his work with

his art—Wallace loved the visual aesthetics of the road itself, a highway placed within a distinctive natural landscape, a visual message that celebrated the marriage of modernity and nature. Henrietta knew when it was coming, that roadside stop. She remembered, "We always took a picture of a road that was always curving. I got so I'd be riding along, and I'd look ahead and I'd think, 'there's a picture.' And I would know just when he was going to take a picture. He took beautiful pictures." Over the years, hundreds of Wallace's images were filed by highway number, both a reflection of his work on particular highway projects as well as an acknowledgment of how he organized his thinking about Arizona.

Wallace's other tastes in photography were eclectic. He loved wild nature in Arizona. He photographed clouds, lightning, flowering cacti, mountain ranges, desert scenery, rivers, and canyons, as well as snakes, coyotes, deer, bears, and more. Humanized landscapes also attracted him: he captured street scenes in Phoenix; panoramas (often with multiple frames) of Tucson; distinctive structures such as churches, schools, dams, and depots; small-town Main Streets; farm and ranch scenes; and (one of his favorites) the extensive mining developments that were transforming the state in the early and mid-twentieth century. He had a soft spot for history, both deep-time landscapes reflected in desert pictographs and Pueblo-style ruins, as well as the more recent dramas of Spanish missions and American-era forts. In the aestheticized Anglo conventions of the time, he was drawn to the state's contemporary Native American populations, fascinated by their connections to place and drawn to their distinctive trading posts, hogans, pottery, basketry, and rugs. I enjoyed the fact that, for Norman, mining smelters, prickly-pear cacti in bloom, and highway signs all deserved attention. Wallace recognized beauty in Arizona in all its manifold forms, and he made it his life to find and photograph it.

Arizona's Twentieth-Century Transformations

When Norman set foot in Arizona Territory in 1906, the interior Southwest was barely removed from the first generation of Anglo settlement. By the time Wallace died seventy-seven years later, he had spent much of his life in a part of the United States that had been utterly transformed by population growth, the automobile, and a post–World War II economy that put Arizona on the map as a major center of investment, urbanization, and amenity-based tourism. Wallace's images date between 1912 and 1950, and my own repeat views were taken between 2016 and 2018.

Briefly turn back the clock and imagine Arizona as Wallace initially encountered it.[10] When he arrived in Tucson in 1906, less than two hundred thousand people lived in the entire territory. The city boasted a population of about ten thousand, making it the territory's largest urban center. Wallace stepped into a multiracial society: Tucson—and all of southern Arizona that was once part of the Gadsden Purchase (added to the United States in 1853)—retained strong cultural and economic ties with Mexico. Tucson's Hispanic population dominated many of the city's neighborhoods. In addition, Arizona's First Peoples added important cultural diversity throughout the territory, including the Tohono O'odham settlements just to the south and west of Tucson.

Two major rail lines—both completed in the 1880s—defined the region's economic geography. The famed Santa Fe line already promoted the scenic and exotic character of its east–west transect across the northern part of the territory: it roughly followed the 35th parallel on a track (followed later by US 66) through Holbrook, Winslow, Flagstaff, and Kingman. To the south, the Southern Pacific Railroad dominated

economic activity through Tucson and Phoenix.

In addition to these trunk alignments, shorter connections reached growing industrial copper mining centers such as Clifton and Globe. These centers attracted capital and diverse workers from around the world, and they featured their own dramatic brand of landscape transformation. Elsewhere an early tourist link brought sightseers to the brink of the Grand Canyon's South Rim, where the famed El Tovar Hotel (owned by the Santa Fe Railway) opened a year before Wallace arrived. Arizona's largest agricultural population clustered in the Salt River Valley surrounding Phoenix, a pattern that would be reinforced following the completion of the Roosevelt Dam in 1911.

Many parts of Arizona were isolated and sparsely populated by Euro-Americans in 1906, far beyond railroads or even decent wagon roads. Some of this was ranching country, and outside of the harsh western deserts, large cattle and sheep operations were based in favored areas blessed with sufficient moisture. Elsewhere Arizona's diverse natural settings defined the landscape, and several physical subregions dominated the scene: across the south and west, slices of the Mohave, Sonoran, and Chihuahuan Deserts offered a mix of isolated mountain ranges surrounded by arid valleys and dry lake beds. The cooler, wetter, and more forested Mogollon Rim draped across the central highlands and included the pine-studded White Mountains in the east as well as the San Francisco Peaks in the north-central part of the territory. Finally, northern Arizona's Colorado Plateau offered sparsely populated canyons and buttes and spectacular red-rock country from the Grand Canyon east to Canyon de Chelly and Monument Valley.

In the popular imagination of early twentieth-century America, Arizona remained remote and exotic. Some of its regional character remained fixed in the formative frontier era of the late nineteenth century, images and narratives that featured bizarre plants and animals, spectacular but largely barren terrain, and a human population barely removed from the days of Cochise and Geronimo (who had been captured and pacified in 1872 and 1886, respectively). When Wallace arrived in Tucson, Zane Grey was still four years away from publishing *The Heritage of the Desert*, the first of his wildly popular and place-defining novels of the Southwest frontier.[11]

By 1900, however, aesthetic ideas about desert landscapes were already changing, and Wallace's fascination with its plant life and austere terrain suggest he was sympathetic to a new generation of writers who celebrated the desert's beauty and sublimity. John C. Van Dyke's *The Desert* (1901), Mary Austin's *Land of Little Rain* (1903), and George Wharton James's *The Wonders of the Colorado Desert* (1906) were already popular books when Wallace stepped off the train in Tucson. These writers celebrated the desert's beauty and its restorative qualities.[12] Indeed, both Phoenix and Tucson became nationally recognized for their healthy, dry air and were popular destinations among tuberculosis patients seeking respiratory relief out West.[13]

Between 1920 and 1960 Wallace witnessed more radical change and tremendous economic and population growth in Arizona. These were precisely the decades when Wallace wandered the state so widely, capturing in his photographs many of the transformations he encountered. The state's population boomed, growing from around 340,000 people in 1920 to more than 1.3 million forty years later. In Tucson, where he spent many of his earlier years, Wallace witnessed a town of 20,000 become a city of 200,000. In 1950 Wallace and Henrietta moved their home base from Tucson to Phoenix

(where they remained) and watched that city's population quadruple in a decade to more than 400,000.

During Wallace's time these were changes reflecting and reinforcing an optimistic, progressive vision for the state and all of the West. Landscapes were being improved, made more useful, accessible, and valuable. Human ingenuity, new technology, and enlightened private and public investments were combining to make Arizona a land of opportunity. It was a world of monumental dams, productive mines, and blossoming cities and retirement communities. It was an era when the Arizona dream—creating modern life amid spectacular natural landscapes—seemed possible. The Colorado River Compact (1922), the western-themed Biltmore Hotel in Phoenix (1929), the epic Boulder (now Hoover) Dam (1935), and Sun City (1960) were all part of the dream, a manifestation of a better future taking shape beneath the desert sun. Highways and automobility made the dream possible: between 1920 and 1960 thousands of miles of Arizona's paved highway network became a permanent fixture on the landscape, recalculating the cost of distance across the state, drawing its once-isolated corners closer together.

Wallace participated and rejoiced in this portion of the dream; with the zeal of a road builder, he celebrated the connection between the high-speed highway and this progressive, optimistic vision of Arizona's future. Norman's mind-set echoed the motto of the Arizona State Highway Department: "Civilization Follows the Improved Highway." In the opening to one of his essays that appeared in *Arizona Highways* in 1936, he described in heroic terms US 70's transect through the mountains east of Phoenix:

Through central Arizona runs a thin black line, alive with motion, day or night. Over the mountain pass, down the rocky gorge, across the deep arroyo, and then up again, wrestling with another of Nature's efforts to block man's new mode of transport, winds the thin, black line. Transcontinental traffic admits of no barrier and chafes at the least obstruction.[14]

What became of the Arizona dream? That was part of my own curiosity as I followed in Norman's footsteps. Stand in his shoes, look at the same landscapes sixty to one hundred years after he did, and ponder what you see. As I traveled Arizona's busy interstates, navigated crowded tourist towns, and fought rush-hour traffic, it became obvious that Arizona's growth story—with a few minor interruptions—has continued into the present. No doubt Wallace would smile watching me dodge multiple lanes of fast-moving traffic to capture a scene once out on the open desert!

More than seven million people live in the state in 2020, almost a tenfold increase since 1950. It takes more than an hour (on a good day) to drive from one end of Phoenix to the other. More than four million people live in the metropolitan area, and Phoenix is now the nation's fifth-largest city. About one-third of the state's population claims Hispanic heritage (slightly less than when Wallace arrived in 1906), and more than 70 percent of these residents have US citizenship.

The economic drivers powering Arizona's growth have become more diverse: while the state still benefits from its legacy as a ranching, farming, and mining center and its popularity as a tourist and retirement destination, much of the twenty-first-century expansion comes from hi-tech manufacturing, financial services, rampant real-estate development, cross-border trade with Mexico, and varied health- and transportation-related services.[15] No doubt the Arizona dream still shines brightly for many who call it home today, but its defining features have

changed with the times, and its cumulative impacts on the landscape—especially in the form of urban sprawl, hundreds of mega-subdivisions, and multiplying second-home tracts—would probably leave Wallace speechless. For better or worse, I do think Norman—the highway engineer—would get a thrill out of cruising through metropolitan Phoenix on Interstate 10, watching five lanes of traffic flow by in each direction. But he would also appreciate the fact that Arizona's transformative growth has been very uneven: a couple of hours away, there are still miles of open space beyond the suburban fringe and growing clusters of exurban development. Here, landscapes have changed more slowly and more subtly. In many of these localities, he might readily recognize the scene—the same rocky outcrop, oak tree, rambling ranch house, or quieter byway that caught his eye a century ago.

Riding Shotgun with Norman Wallace

My own relationship with Norman began anonymously but incandescently. It proved to be an enduring, serendipitous encounter. When I was a child in southern California, our family inherited several beautifully bound volumes of *Arizona Highways*, dated between 1946 and 1960. I remember poring over the colorful pages with a road map draped across my lap, marveling at the red-tinted rocks, the desert landscapes, and the exotic cacti that filled each issue. I remember finding places on the map, marking particular articles in the magazine, conjuring future family vacations. No doubt Norman's photographs, even his short articles on Arizona's highways and history, were part of my visual feasting. Finally I convinced my family to vacation there in 1970, and we took in Hoover Dam, the Grand Canyon, Monument Valley, and the Navajo Country. I wasn't

disappointed, and as the trip's designated fourteen-year-old photographer, I faithfully captured photographs of Navajo hogans, desert thunderheads, and canyon vistas with my Kodak Instamatic 104 camera.

Years pass. Perhaps predictably, my interests in travel, photography, and the western American landscape conspired to make me an academic geographer. Joyfully I realized that I could make a living doing what I loved. More years pass, along with graduate education in upstate New York and college teaching jobs in Georgia and Montana. Fast forward to 2010 and a research trip to Arizona. I was working on a book on the larger American West (*How to Read the American West: A Field Guide*) that involved both fieldwork and time in archives.[16] The project brought me to the Arizona Historical Society Research Library in Tucson. In the hunt for good historical views of Arizona, I stumbled across the Norman Wallace Collection. It took my breath away: box after box filled with sharp, clearly located vintage views of the state, ranging from the 1910s to the 1960s. Parts of the collection had been donated to the Arizona Historical Society in 1984 by Henrietta, Norman's widow, and it was supplemented in 1999 by another donation from the archives of *Arizona Highways*, which had published many of Wallace's images in earlier years. The well-organized files of images took me on every major and minor Arizona highway and from every settlement—in neat alphabetized order—from Ajo to Yuma. At the time, I selected some images for my other project, but I remembered the encounter. Who was this guy? What was he doing in every Arizona town, driving along every highway?

Even before my other book was published in 2014, I vicariously struck up a closer relationship with Norman. Returning to Tucson, I began a more careful and systematic exploration of the collection. I began to learn a bit about Wallace from his oral history and from personal documents in

the collection. I discovered the remarkable log books that documented his photography, but I was initially confounded by the many layers of scribbling, notes, dates, and place-names that filled the pages. Clearly these were hieroglyphics made by Norman for himself, not for me. Boring in more closely, I gradually translated what I found, connecting entries with particular images, file folders, and trips, some for pleasure, some for his work with the Highway Department. I realized I could hold an image in my hand taken by Norman along US 66 in 1933 and then find the exact date, even the time of day, of the photograph in his log book. Many times I could tell where he slept that night, the car he was driving, who he was with, or whether it rained or not. This raised new possibilities. As our vicarious relationship deepened, I thought about how to tell Norman's story and what that story might be, realizing it might involve us both.

One of the special delights I discovered deep in Norman's archives and within his log books was his early fascination with color photography, beginning in the 1930s. I found two wondrous boxes (Boxes 40 and 41) of his color views within the collection: these treasures included 35mm slides as well as 4 × 5 and 5 × 7

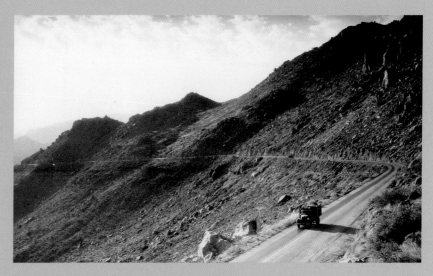

Yarnell Hill along US 89, near Desert View Point, 1933. AHS, PC180, Folder 105, #1515.

color transparencies. I then found references to his "5 × 7 Kodachrome Sets" in Log Book 12 that showcased these special collections of color views, including roadside scenes, nature studies, historical landscapes, and even Boulder Dam. I decided to include several of these color-color comparisons in my project and found that they seemed to narrow the apparent spread of years between our two views, a great reminder that the world in 1940 was indeed *not* experienced in black and white.

I was already familiar with the mechanics, challenges, and rewards of repeat photography:

I had published a book of roadside rephotography in Montana in 2006 (*On the Road Again: Montana's Changing Landscape*) and had enjoyed thinking through what was changing in the landscape and why.[17] But it had been a one-way relationship with the images themselves: the Montana views were rarely signed and were taken by different photographers, some professional, some amateur. But Norman offered something different. The well-documented photographs, along with the log books, gave me an opportunity to see Arizona through his eyes, to ride alongside him, retracing his footsteps

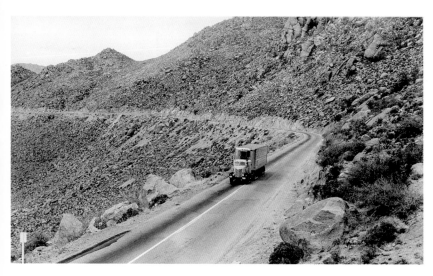

Yarnell Hill along US 89, near Desert View Point, 1949. AHS, PC180, Folder 106, #1511.

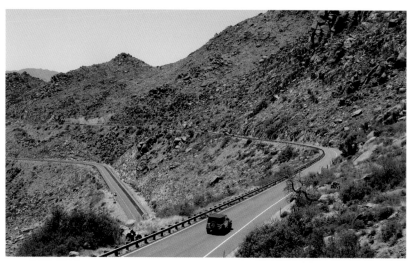

Yarnell Hill along US 89, near Desert View Point, 2016. Author photograph.

through the same rocky hillsides he once scrambled along and discovering what drew his gaze, how he composed a picture, what he chose to ignore, and in the end what he produced. More than that, it gave me the chance to revisit the scene with my own camera (a digital Canon EOS 60D), repeat Norman's work, and then learn from what I found.

I pored through the archival collection, days of visual sifting, finding the best and most interesting possibilities for repeat photography. As I worked through his images, I also delighted in the fact that Norman had done the same thing in several instances: he had returned to the same spot years later to produce his own rephotographed images. In one instance I eventually added a third view to a pair of images he had taken on Yarnell Hill southwest of Prescott in 1933 and 1949. Wallace had enjoyed lining up trucks from different eras in his own reshoot. My 2017 retake—done near

Desert View near the top of the hill—revealed even more dramatic highway alterations as the entire grade had been reengineered, making two separate one-way roads to increase speed and safety. Like several of Wallace's other rephotography shoots, this image drew blood: not content to stand on the road and simply take his picture, Norman had scrambled up the steep, brushy slope on the north side of the highway to gather in a better view. My adventure up the same hill produced several scratches and cuts as well as a number of bemused looks from passing motorists. But Norman was right: the view was terrific!

My experiences on Yarnell Hill were repeated in dozens of other localities around the state over the next three years. With a car filled with cameras, my own log books, old road maps, and Norman's original images, I retraced his travels to every corner of the state. Gradually our friendship

grew as I came to understand how he framed his photographs and where he would usually go to capture a preferred view. At every location I would often spend hours pacing a road or hillside with his image in hand. Ideally I found the spot in a way that let me stand literally in his footsteps. I learned to bend down just a tad on some shots; Norman was shorter than me and it could make a difference. I saw he was blessed with a photographer's eye for composition that made his views interesting and entertaining. I also saw how the passing of time scrambled up visual elements in the landscape in surprising ways—popping a billboard into the frame, losing a tree, or altering a road alignment to change the look of a scene.

Some images became predictable: Wallace enjoyed the panoramic view, so I often found myself—like on Yarnell Hill—scrambling up steep slopes and taking long cross-country hikes. I learned to lace up boots every morning and carry plenty of water. Wallace also enjoyed the street view, positioning himself precisely in the middle of an urban avenue or open highway, capturing an image defined by the linear lines of the road itself and the landscapes that defined its borders. For my part, reproducing these earlier center-line views often took a leap of faith that

Norman was watching over me, keeping me safe as I dashed in between traffic on some four- or six-lane highway.

Days in the field were carefully planned to visit somewhere between two and four of Norman's sites, but I had to include travel distances (often over a hundred miles) between locations as well as time of day to reproduce strong shadows effectively, and I had to stay one step ahead of dark clouds, haze, or dust. Often I revisited a site multiple times to reproduce Norman's image. Like Norman, I tried to live cheaply and casually along the road: according to his wife, Wallace's dinner might consist of a quart of milk, some graham crackers, and a tin of sardines. My equivalent was the collection of fruit, bottled water, and M&M's I stashed behind me on the floor of the back seat. Like his, my days in the field were long, typically beginning in the cool moments of early morning, surviving long hours of Arizona's midday heat, and continuing into the late afternoon until changing light conditions ended my day.

Some of my favorite experiences with Norman took me to the places I knew were special to him, places he had often rephotographed and revisited many times. While not a traditionally religious man (I never found a single journal

entry that associated Sundays with the inside of a church), Norman became enamored with the aesthetic beauty and the historical associations at Mission San Xavier del Bac, near Tucson. Father Wandt, caretaker there in the late 1920s, gave Wallace an insider's tour of the entire church and its grounds, and Norman loved returning to capture the setting and the nearby Indian houses in various daily and seasonal moods. It is the oldest European landmark in Arizona. This remarkable Baroque-Moorish-style structure—completed in 1797—must have caught his eye soon after his arrival in Tucson, and he returned numerous times to photograph it from a variety of angles. He had one of his images of the church chosen for the cover of *Arizona Highways* in 1932, and he described it as "the most beautiful of all the missions" in 1935.[18] His early color view that I used was taken in 1941, and it gave me a special opportunity to appreciate the scene (taken from a nearby hill) and enjoy the same rich mix of blue skies, nearby irrigated fields, and spectacular white exterior walls and bell towers.

Another favorite setting I shared with Norman was US 66, the fabled highway that had been the site of so many of his improvement projects and realignments. He also enjoyed the

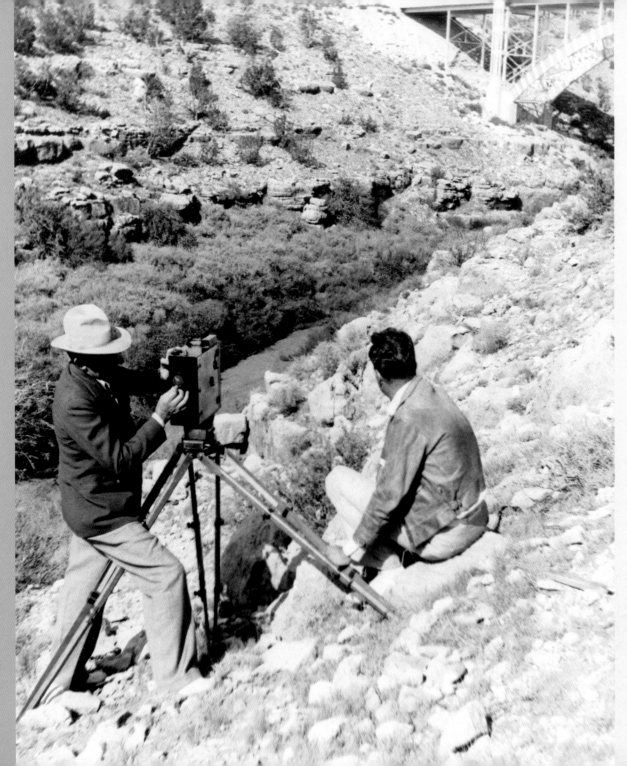

Norman Wallace (left), positioning camera near bridge, undated. AHS, PC180, Folder 210, #M.

varied localities encountered along the way. For Norman the road was its own narrative of scenery and space, a linear landscape he loved to photograph. He produced many small-town portraits along the route, and I explored his many images of communities such as Holbrook, Winslow, Flagstaff, and Ash Fork. He also captured the open country between towns, wondrous sweeping views on the Navajo Reservation all the way west to the old grade up Sitgreaves Pass near Oatman. Both locations—originally photographed in 1933—have been long bypassed by the modern interstate, but they gave me a feel for the US 66 landscape that Wallace knew from an earlier era.

I also enjoyed encountering other out-of-the-way landscapes with Norman that hadn't changed much. It was easier to see what he saw, to put myself behind his camera and gather in the scene. I had good luck finding one spot in the eastern part of the state, near Springerville. The details on the image were scant: I knew he took it in the summer of 1933, that it was on State Highway 81, and that it was several miles out of town. I spent a clueless afternoon cruising the main highway north of Springerville, trying in vain to line up the buttes and hills to reproduce his view. Finally I realized that the entire route had been significantly realigned. Luckily I blundered onto Apache County Route 4365—a winding gravel road that meandered northwest into distant hills—and saw the scene Wallace had photographed come together as I glanced back over my shoulder. Once I arrived on the lava-studded hill and looked southeast, I was back in 1933, standing with Norman, enjoying the same view.

In the galleries that follow, appreciate that each pair of images tells three stories. First, there is Norman's story and what put him there. Sometimes it was work, but often it was pleasure that compelled him to haul his camera out of the back seat and make a record of what he found. Then there is my story of finding what he found, a small but special part of my day in the field that brought me to where he stood decades earlier. Pacing the ground, adjusting the lens, my digital camera capturing what Norman saw, what had changed. Third, there is the story of what *you* see by letting your eyes compare views across the page. In places, I offer tentative observations, but you decide. Feel free to write your own captions.

Notes

1. Much of what I learned about Norman Wallace is available in the Norman Wallace Manuscript Collection (PC180) at the Arizona Historical Society (AHS) in Tucson. For more details, see http://www.arizona historicalsociety.org/wp-content/upLoads/library_PC_Wallace-Norman G.pdf.

2. Henrietta Wallace's oral interview is the source for her quotations in this chapter. See Henrietta Wallace, AV0619, 1987, AHS. For Norman Wallace's oral interview, see AV0366, 1975, AHS.

3. For Wallace's log books, see PC180, Boxes 58 and 59.

4. Wallace's 1931 trip can be followed in Log Book 1, PC180, Box 58.

5. Norman Wallace, "From a Roadbuilders Notebook," *Arizona Highways*, November 1940.

6. For the larger story of the development of photography in the American West and how particular photographers recorded western landscapes, see Martha A. Sandweiss, *Print the Legend: Photography and the American West* (New Haven, CT: Yale University Press, 2002) and Rachel M. Sailor, *Meaningful Places: Landscape Photographers in the Nineteenth-Century American West* (Albuquerque: University of New Mexico Press, 2014).

7. For more details on some of Arizona's pioneer photographers, see Robert L. Spude, "Shadow Catchers: A Portrait of Arizona's Pioneer Photographers, 1863–1883," *The Journal of Arizona History* 30, no. 3 (Autumn 1989): 233–50; Thomas Vaughan, "C. S. Fly: Pioneer Photojournalist," *The Journal of Arizona History* 30, no. 3 (Autumn 1989): 303–18; Bruce Hooper, "Willis Pearson Haynes: Arizona Photographer," *The Journal of Arizona History* 33, no. 1 (Spring 1992): 85–98; Jeremy Rowe, *Photographers in Arizona, 1850–1920: A History and Directory* (Nevada City, CA: Carl Mautz Publishing, 1997); and Jeremy Rowe, "George H. Rothrock: Arizona Pioneer Photographer," *The Journal of Arizona History* 49, no. 4 (Winter 2008): 355–83.

8. The success of the Frashers and their remarkable commercial postcard business across Arizona and the West is summarized in Jeremy Rowe, "Have Camera, Will Travel: Arizona Roadside Images by Burton Frasher," *The Journal of Arizona History* 51, no. 4 (Winter 2010): 337–66.

9. Among their many professional accomplishments, both Josef Muench and Darwin Van Campen contributed hundreds of scenic images to *Arizona Highways* magazine. See, for example, their images in the April 1966 issue (42, no. 4) on Arizona's Payson-Rim Country. For more information on the career of Tad Nichols and his amazing photographs of Glen Canyon and elsewhere, see https://library.nau.edu/speccoll/blog/2014/08/tad-nichols-images-of-a-lost-world-glen-canyon/. Mark Klett's remarkable contributions to western landscape photography and to repeat photography can be explored at http://www.markklettphotography.com/. Allen Dutton's long visual love affair with Arizona is celebrated in his *Arizona Then and Now* (Englewood, CO: Westcliffe Publishers, 2002).

10. The best one-volume history of Arizona is Thomas E. Sheridan, *Arizona: A History* (Tucson: University of Arizona Press, 2012). For more historical background on Arizona, I also used Federal Writers' Project, *Arizona: A State Guide* (New York: Hastings House, 1940); D. W. Meinig, *Southwest: Three Peoples in Geographical Change, 1600–1970* (New York: Oxford University Press, 1971); and Marshall Trimble, *Roadside History of Arizona* (Missoula: Mountain Press, 1986).

11. Zane Grey, *The Heritage of the Desert: A Novel* (New York: Harper Brothers, 1910).

12. John C. Van Dyke, *The Desert* (New York: C. Scribner's Sons, 1901); Mary Austin, *Land of Little Rain* (Cambridge: Houghton, Mifflin, 1903); George Wharton James, *The Wonders of the Colorado Desert* (Boston: Little, Brown and Company, 1906).

13. See Sheridan, *Arizona*, 238–41, and Michael F. Logan, *Desert Cities: The Environmental History of Phoenix and Tucson* (Pittsburgh: University of Pittsburgh Press, 2006).

14. Norman Wallace, "Highway Adventure," *Arizona Highways*, March 1936.

15. Arizona's more recent economic transformation is chronicled in Sheridan, *Arizona*, 276–413.

16. William Wyckoff, *How to Read the American West: A Field Guide* (Seattle: University of Washington Press, 2014).

17. William Wyckoff, *On the Road Again: Montana's Changing Landscape* (Seattle: University of Washington Press, 2006).

18. Norman Wallace, "Scenic 89 From Mexico to Utah," *Arizona Highways*, February 1935.

NATURE'S PALETTE

Wallace was twenty-one years old when he arrived in Arizona Territory, a midwestern boy who had grown up near the Ohio River surrounded by green hills and small farms. Southern Arizona must have seemed an austere place, but Norman embraced the desert landscape, learned all about the exotic plants that grew there, explored the region's complex topography, and was enraptured by the skies and cloudscapes that mesmerized him until he died. He also loved Arizona's natural extremes: he photographed lightning, flood damage, snowdrifts, and wildfires. Many special places around the state drew his enduring attention, and he had a good eye for natural settings Arizonans still revere: he could never get enough of the Grand Canyon, Oak Creek Canyon, the Santa Catalina Mountains, the Superstition Range, Canyon de Chelly, the White Mountains, the Petrified Forest, or the Painted Desert.

opposite West of Springerville (1933). AHS, PC180, Folder 129, #1256.

Norman's photo log books reveal his love affair with the natural world. Read his penciled remarks down the page:

Catalina Mts,
Cactus and Mountains,
Robles Pass—Cholla,
Lone Sahuaro,
4 Kinds of Cactus,
Sunsets.

Each notation was a small encounter with a part of Arizona that Wallace found irresistible. He loved the outdoors: he camped in it, worked in it, and framed many of his pictures around the scenery Arizona generously offered. Many of his short, illustrated articles in *Arizona Highways* focused on nature. He wrote about the seasonal changes one encountered in the state. The essays were careful, detailed descriptions of particular plants with descriptions of their annual life cycles and where you might find them. He knew the Latin names for cacti and could tell you where and when ocotillo bloomed. When he organized and assembled his photographs late in life, he had files for "Cactus Plants, cactus flowers," "Sunsets, Cloud Effects," "Desert Views," "Superstition Mountains," "Wild Animals, Deer,

Snakes, Horses, Bear," and many more slices of Arizona's natural fundament.

Norman taught me a great deal about Arizona's natural world and why he found it fascinating. He brought me to amazing, offbeat places. Many of the sites I revisited took me on dirt roads, sometimes for many miles. I liked rattling along, thinking about his presence there eighty or ninety years earlier as I snaked across the desert or along some remote mountainside, one hairpin turn after the next. Arizona has a great capacity for surprises; I never realized the Pajarito Mountains along the International Border west of Nogales were so beautifully contorted, dappled sparingly with oaks and mesquite. He also took me to the back side of the Chiricahuas near the New Mexico border, to the naked, beautiful Vermillion Cliffs near Marble Canyon, and to the startling cleavage carved by the Little Colorado River just east of the Grand Canyon.

I learned how quickly Arizona's life zones shift over short distances. It's all about elevation change, and many of the highways Norman and I traveled gained or lost thousands of feet within a few miles. My favorite traverse: take the narrow paved road (Coconino County Highway 73) that

leaves Williams, going south through the Kaibab National Forest. I was there on a cool morning in late May, headed for a remote spot Norman had photographed in the Verde Valley, about twenty-five miles away. Ponderosa pines and aspens lined the highway as I passed a few meadows and small ponds. There was no traffic once I left Williams behind, just miles of cool, green forest.

Fifteen minutes later the landscape was changing: as I lost elevation—from about seven thousand feet to five thousand feet in a steady southward drop off the Mogollon Rim—the big pines disappeared, the aspens left me behind, and scrubby pinyon pines, juniper trees, and oaks quickly took over. Better views to the south opened up as the forest shrank, and the temperature warmed a quick fifteen degrees. By the time I lost pavement in a few more miles, my gravel road was in high desert. But my biggest surprise came when I arrived along the Verde River—at the Perkins Ranch—near where Wallace captured his view almost seventy years earlier. The river was lined with towering trees, mostly cottonwoods, and provided an amazing oasis, a slender corridor of cool, lush vegetation amid surrounding semiarid hills. I stopped on the bridge and enjoyed the welcome sound

of the water and the late morning breeze in the cottonwoods. I looked downstream and saw my first great blue heron in Arizona—it seemed an improbable setting for a bird I associated with Rocky Mountain wetlands, but it had found its niche, a run of shaded, quiet water, stalking fish and frogs. Thank you, Norman.

With Norman I also gained an appreciation for nature's impermanence, its fluid, unpredictable penchant for change. Even in the relatively short gap between Norman's photographs and mine, nature's palette had often been reconfigured; the natural world had moved on to something different for a variety of reasons, some related to human beings, some not. Nature never stood still. On my little sojourn to the Verde River on that mild day in May—after I enjoyed my time along the stream—I reconnoitered the nearby hills to rephotograph part of a panorama Norman had created in 1949. He chose the hill I finally found because it offered unobstructed views of the river valley and of the mountains beyond. I liked the spot he picked because it captured plenty of open space in the foreground—a hillslope dipping south to the river and bridge—and centered on the impressive massif of Woodchute Mountain in the distance.

What struck me was how many more trees had crept into the scene between Norman's time and mine and how that had changed the look of the land and the perspective of Norman's original view. Some of the open feel of the earlier view was gone, replaced by invading woodland. The bridge across the Verde was barely visible to me as cottonwoods had crowded along the river, and the once-open intervening slopes had been thickly populated with a forest of small, sturdy junipers. Every other slope in the distance bore similar witness to the change. Ecologists and range managers point to similar processes at work around much of the West, where climate change, better wildfire suppression, and changing practices of livestock grazing are helping promote scrubby juniper forests. This creates both opportunities (for nesting birds) and problems (less productive grazing land), but I found that Arizona was a terrific laboratory to look at the visual evidence that Norman's photographs made possible. My experience along the Verde River made me more aware as I looked at other "natural" landscapes around Arizona: what I was seeing was unlikely to be there in another few decades, and what Norman had captured decades earlier were literally snapshots in time of landscapes that no longer really existed in quite the same way.

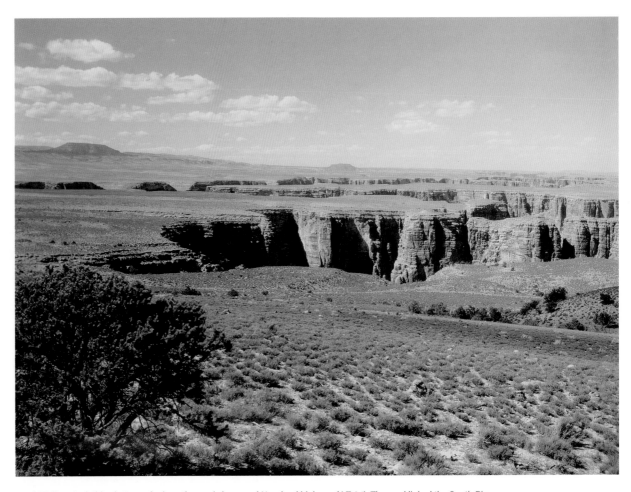

1936 Wallace took this photograph along the newly improved Navahopi highway (AZ 64). The road linked the South Rim of the Grand Canyon to US 89 near Cameron. The million-dollar highway—"oiled and improved"—showcased the deeply incised canyon of the Little Colorado River not far from its junction with the Colorado. Flat-topped Cedar Mountain is to the north (left). Photo reproduced courtesy of the Arizona Historical Society (hereafter AHS), PC149, Folder 5B.

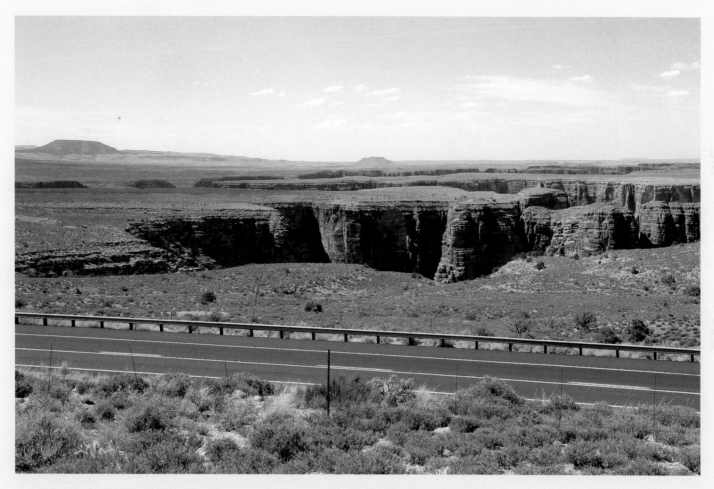

2016 Eighty years later, the abandoned roadbed was drivable, but the pavement was cracking, yielding to time, weather, and neglect. I watched as traffic sped by below me on a newer, high-speed highway. The view north remained endless, delicious, even in one-hundred-degree heat. Author photograph.

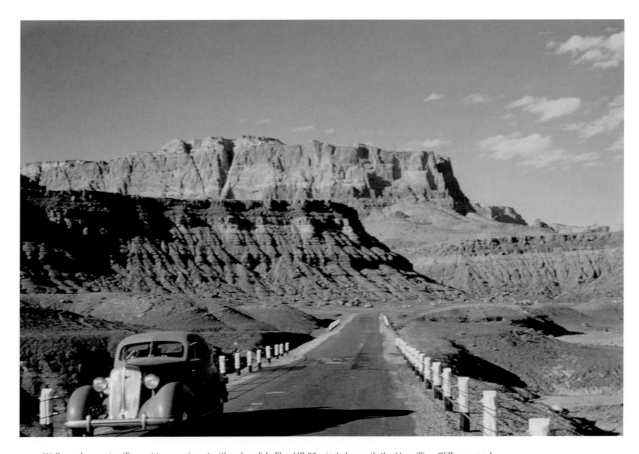

1940 Wallace chose a terrific spot to experiment with color-slide film. US 89 winds beneath the Vermillion Cliffs, a grand palisade of sedimentary rock layers, including lighter-toned Kaibab Limestone and the multihued Chinle Formation. Traffic was light, and Wallace parked his vehicle in the westbound lane. AHS, PC180, Box 40.

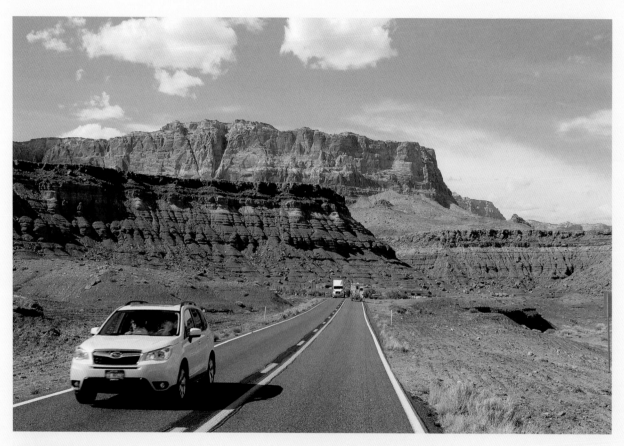

2018 The spot (along US 89A) is just west of the Cliff Dwellers Lodge (in the trees, lower center). Parts of the development (not visible) date to the 1920s, when it was a trading post for local ranchers. My triple challenge: step onto the busy highway, catch a moment of bright sun, and capture a speeding vehicle to replicate Norman's parked car. Author photograph.

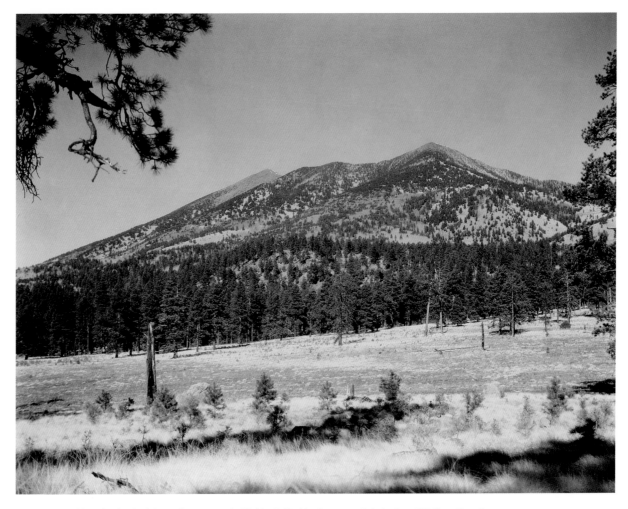

1932 Norman's idea of a Thanksgiving outing was to take his friend, Abe Morrison, up to Schultz Pass (8,100') northwest of Flagstaff. Wallace often took days off to explore and photograph surrounding countryside. This view includes a meadow, ponderosa pine–covered slopes, and the bare volcanic outline of the Peaks (12,633'), Arizona's highest point. AHS, PC180, Folder 292, #0007.

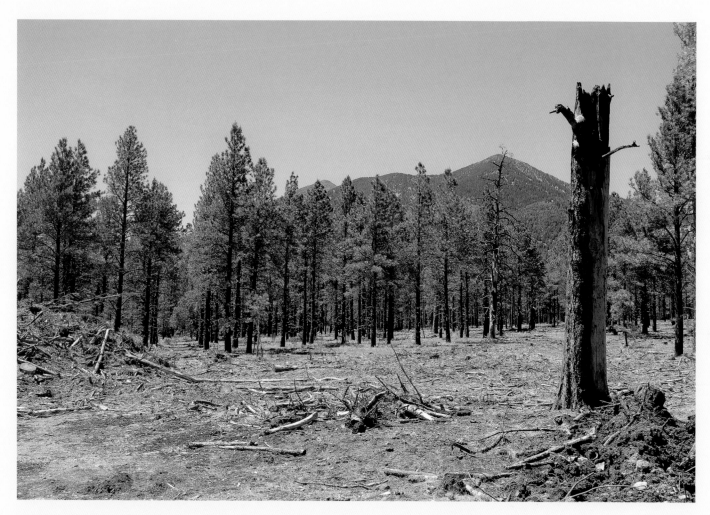

2016 Nature never stands still. My challenge was to see the peaks through the trees to line up ridgelines as precisely as possible. A forest had broadly invaded the meadow since Wallace's Thanksgiving excursion. The invasion is being countered by a tree-thinning and logging operation (see the slash pile, left) designed to reduce the threat of catastrophic blazes and protect Flagstaff's watershed. Author photograph.

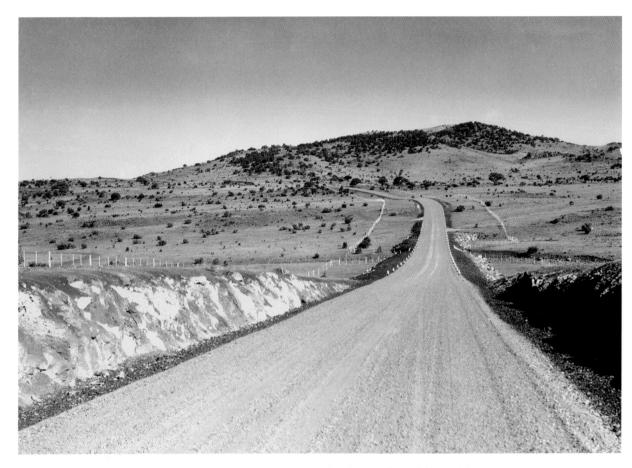

1937 Norman combined work with pleasure. This view was taken on a long spring trip in 1937 that took him to Globe, the Salt River Canyon, St. Johns, the White Mountains, and the Chiricahuas. He photographed bridge construction, highway conditions, small towns, nature scenes, and more. This image looks west, showing an improved stretch of US 60 (east of Show Low) as the road climbs toward Montoso Summit. AHS, PC180, Folder 30, #0727.

2017 The highway alignment and road cut made this easy to find, but the tree invasion (mostly juniper) was remarkable. In eighty years, the landscape changed from open, grassy hillslopes to a mostly forested scene. Fire suppression, livestock grazing, and changing climatic conditions all played a part. I enjoyed contemplating the quiet conquest, listening to the wind in the junipers. Author photograph.

1933 These volcanic tablelands caught Norman's attention along the main highway between Springerville and St. Johns. This summer view looks southeast from a sweeping curve across a sparsely vegetated valley that Wallace called "open and bare country, dotted with cinder cones" in an *Arizona Highways* piece that was published in May of 1935. AHS, PC180, Folder 129, #1256.

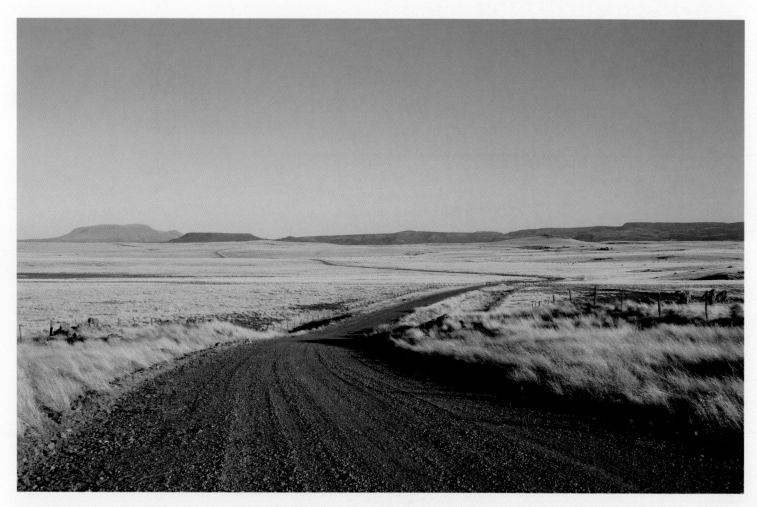

2017 The route is now a lightly maintained byway—Apache County 4365—and it's no longer the main road to anywhere.

This remains ranching country: nearby grasslands appeared thicker than in 1933. In the distance (right), I spotted a small herd

of cattle in the valley. I liked finding the volcanic outcrops in Norman's view (far right) and comparing them with what I saw.

Only one pickup truck per hour made for delicious solitude. Author photograph.

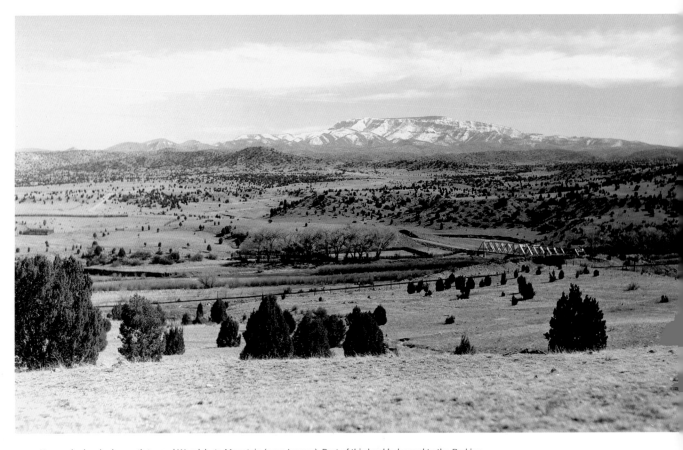

1949 Norman's view looks south toward Woodchute Mountain (near Jerome). Part of this land belonged to the Perkins Ranch, a large cattle-ranching operation in the area since 1900. The single-lane bridge crosses the Verde River. Note the railroad spur line (lower left to center right), part of the Arizona Central Railroad, a subsidiary of the Santa Fe. AHS, PC180, Folder 138, A (top image).

2017 Invading junipers have thickened and cottonwoods along the river have leafed out and are more numerous than in Norman's view. Both the bridge and the railroad tracks remain, made all but invisible by the trees. I listened to cattle from the Perkins Ranch below (left), but I saw no sign of the Verde Canyon Railroad, a tourist line that still makes the daily trip from Clarkdale to Perkinsville. Author photograph.

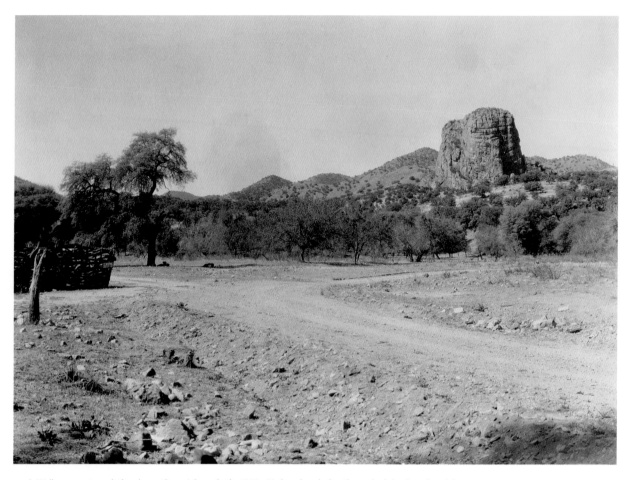

1926 Wallace spent much time in southern Arizona in the 1920s. He loved exploring the region's backroads, mining history, and isolated mountain ranges. In *Arizona Highways* (December 1933) he describes this remote scene near the Mexican border: "The road drops down into Pena Blanca (White Cliff) Valley, where an old corral and water trough . . . lie. . . . oak covered mountains surround the valley. . . . Old Castle Rock, sheer five hundred feet in height, stands as a castle of old at the toe of mountains." AHS, PC180, Folder 287, #0701.

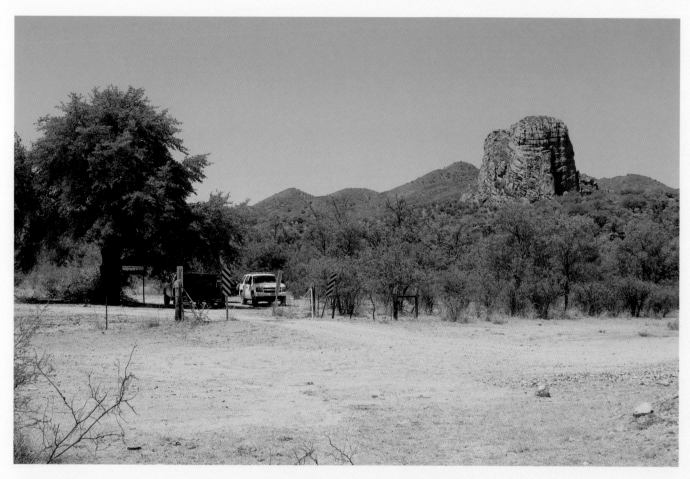

2016 Ninety years later, the place remains off the beaten path. Although the corral vanished, I enjoyed seeing the nearby oak tree on the flats. Two major changes: as ecological space, with reduced fires and historical grazing, note the widespread invasion of mesquite; as social space, note the Border Patrol agents under the oak tree. Unlike Norman's time, this is now a more visibly contested landscape, less quiet than it appears. Author photograph.

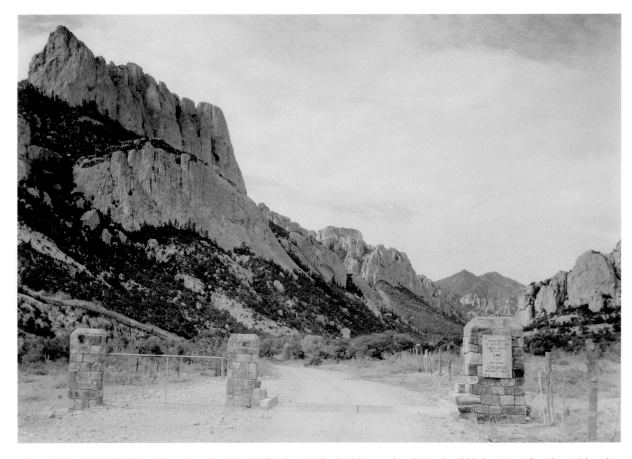

1938 Wallace worked on highway projects near Duncan and Clifton in 1938, allowing him to explore the nearby Chiricahuas, one of southeast Arizona's most spectacular mountain ranges. Apaches called these rugged canyons home until the late nineteenth century. Cattle ranches appeared, beginning in the 1870s. In 1902 the Chiricahua (later Coronado) Forest Reserve was created. Wallace paused here at the Forest Service boundary, capturing the impressive cliffs that line the entrance to Cave Creek Canyon. AHS, PC180, Folder 283, #0458.

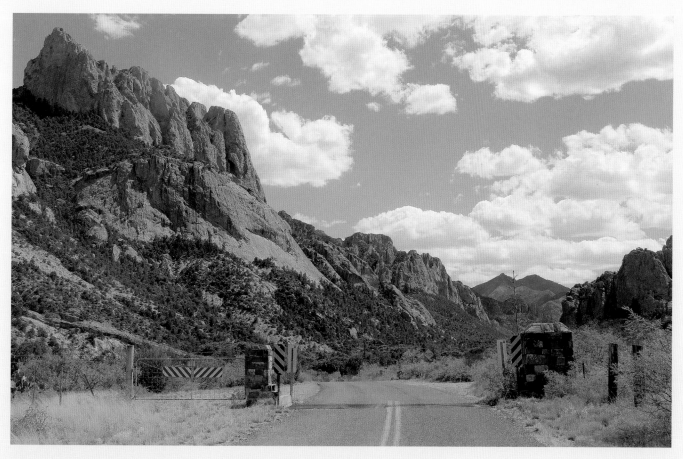

2016 In his "Basin and Range Forms in the Chiricahua Area" (1930), geographer Carl Sauer was impressed by "the penetration of the range by good-sized canyons with broad, but rapidly ascending floors." His words rang true as I enjoyed the afternoon sun at the same national forest boundary Norman had photographed. The sign was gone, but I matched up stones on two surviving pillars. Author photograph.

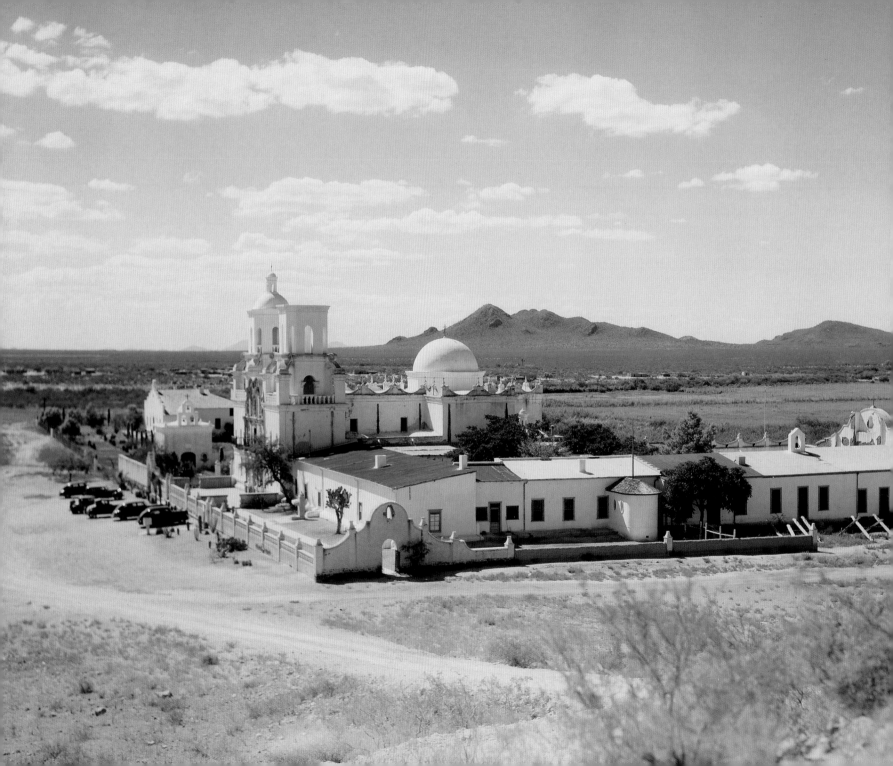

3

MONUMENTS
TO HISTORY

Pueblo ruins, territorial forts, and old churches fascinated Norman.
He checked out library books on southwestern archaeology, followed
Coronado's route through Arizona and New Mexico, and photographed
dozens of historical sites around the state. I don't know what sparked
Norman's historical imagination, but he was like a moth drawn to that
flame. It may have begun in northern Mexico in 1915 when he was working
on a railroad surveying and construction job. The crew was operating a
steam shovel along the transit line, and they hit an old Indian burial site.
Immediately Norman's camera appeared, and he photographed the scene,
noting the incident in his log book.

opposite Mission San Xavier del Bac, 1941. AHS, PC180, Box 41.

Not surprisingly, given his photographer's eye, Norman's enduring passion for history was seen through the lens of landscape. What had happened there? Is this the canyon where Cochise defended himself against his enemies? Did Coronado look at these same foundations and decaying rubble at Hawikuh? Is this where the lost gold mine might be hidden in the Superstition Mountains? Wallace used his sensibility for landscape and place to literally frame his encounters with history. And he felt a need to photograph these settings where history had unfolded. It was almost as if he saw it as his responsibility to document these sites—perhaps before they were forgotten or destroyed.

The explicitly historical images—and the ways he organized them in his collection—suggest that Wallace was particularly attracted to certain kinds of historical narratives. First, he was drawn to the region's Native peoples and their long historical associations with the land. Second, he was enamored with the heroic aura of the Spanish period and how its famous trails and missions reflected that bygone era. Third, Wallace embraced the American frontier story in Arizona: he visited and collected images of every major fort in the state, and he also retraced the steps of nineteenth-century explorers, photographing many of the localities they encountered, imagining what it was like to be a part of the landscape in those times. Norman also photographed monuments that celebrated heritage, and some of this was actually done in his work for the Highway Department, reflecting that agency's involvement with roadside markers and signs.

Most of Wallace's subjects for these historical images were predictable and reflected the popular culture of the times. But his photographs were well executed, and they revealed his enjoyment that came with capturing an image that suggested something about the state's rich and culturally diverse past. He wanted to stand at the spot where in 1857 Colonel Beale had bedded down his camel herd (near Seligman) on their famous exploratory expedition across the territory. He wanted to imagine the scene, compare Beale's journals with his own observations and experience.

He was also drawn to people who studied history for a living. According to his log books, Norman spent time in 1936 with a paleontologist who was unearthing a "Pthytosarous, or ancient crocodile" in the Painted Desert east of Cameron. He photographed the excavation site and befriended "Dr. Brown," who led the expedition from the Museum of Natural History in New York. Similarly, he knew rangers at Tumacácori National Monument south of Tucson and was fascinated by their excavations near the chapel. He photographed the work as it unfolded, and he repeatedly returned to the site in later years.

Wallace also enjoyed capturing history as it happened. He often informally photographed important celebrations, parades, and state events in Phoenix and Tucson. No doubt his most exciting assignment—of a more official nature—came in 1935 with the completion of Boulder Dam. Already well-known in the State Highway Department as an excellent photographer, Wallace was invited along by the editor of *Arizona Highways* magazine to capture the big event that featured a public ceremony and a visit by President Franklin Roosevelt. Wallace beamed in his log books that he was given an official press pass that allowed him to brush shoulders with career photographers as he recorded the festivities. In later years Norman returned to the dam often, capturing its impressive size and spectacular setting.

More than anything, Norman loved ruins. He loved reading about them, photographing them, and sleeping in them. He visited Casa Grande (the Hohokam archaeological site became a National Monument in 1918)

between Tucson and Phoenix many times, even as an old man. Close to his Tucson base, Wallace also enjoyed Fort Lowell just out of town, capturing the fort's remnant walls in various light. One of his favorite spots in the state was Wupatki National Monument northeast of Flagstaff. One of the Southwest's great Pueblo-era sites, Wupatki's ruins have been abandoned since the thirteenth century, but the locality's dry climate and isolation have preserved impressive remains.

I was struck—like Norman—by the centuries of human activity that had unfolded at this place and by the ongoing restorative work undertaken by the National Park Service. Collapsed walls and stone stairs had quietly, carefully been put back into the landscape since Norman's time. Interpretive signs and a pathway guided visitors from a nearby parking lot. I thought about how each era—Norman's and mine—experienced history in this place a bit differently. Norman was free to wander, scamper, and scramble everywhere, to unroll his sleeping bag right there on the spot. We now live in more regulated times, but also in an era that respects the past and its inhabitants with different sensibilities than one encountered decades earlier. I loved the same afternoon light that Norman found. The few visitors exploring the ruins seemed to enjoy or at least tolerate my presence as I took dozens of digital images at the same gentle bend in the trail.

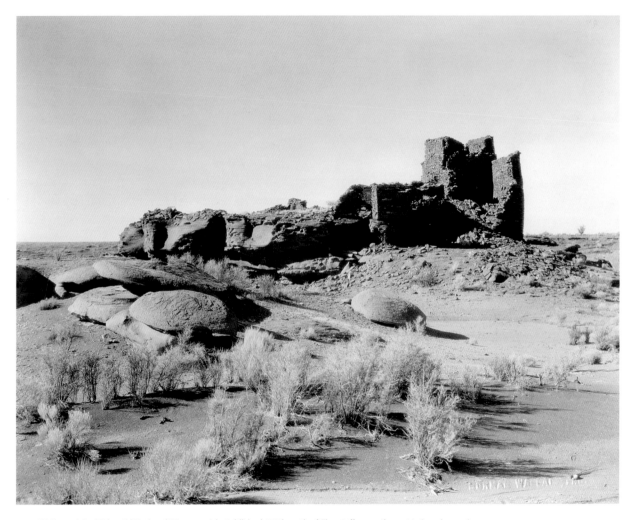

1932 Wallace visited Wupatki National Monument (established 1924) north of Flagstaff many times. He loved camping there and sketching and photographing the ruins. Wukoki was one of his favorites: the pueblo, built with slabs of Moenkopi sandstone, was occupied by Ancestral Puebloans between 1120 and 1210 AD. Partially excavated in 1896, the site was still relatively undisturbed on Norman's early visits to the Monument. AHS, PC180, Folder 360, #0469.

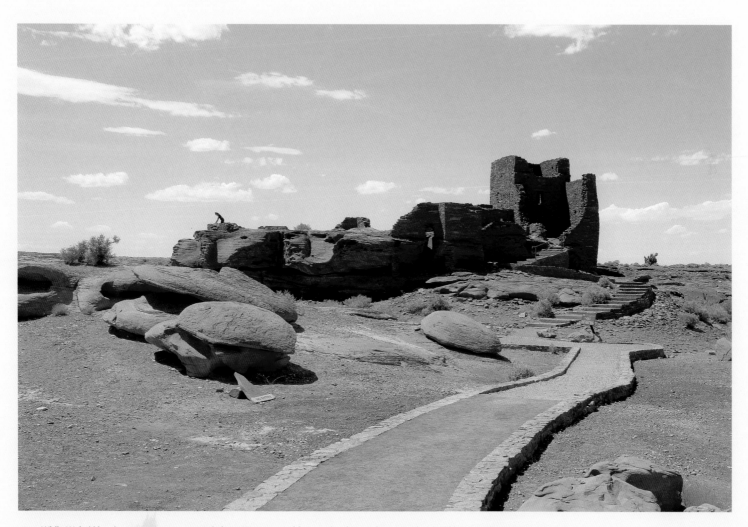

2017 While Wukoki has become a more managed place, Norman would recognize the omnipresent wind, bright sun, and sweet juxtaposition of sandstone and sky. Subtle changes tell stories of growing visitation and strategies of stabilization and interpretation: Major preservation efforts in 1941 and 1954 cleared rubble, braced walls, and repaired mortar. The trail and steps came in 1985, replacing a rough path. Now, more than 230,000 people visit the monument annually. Author photograph.

CANYON DE CHELLY

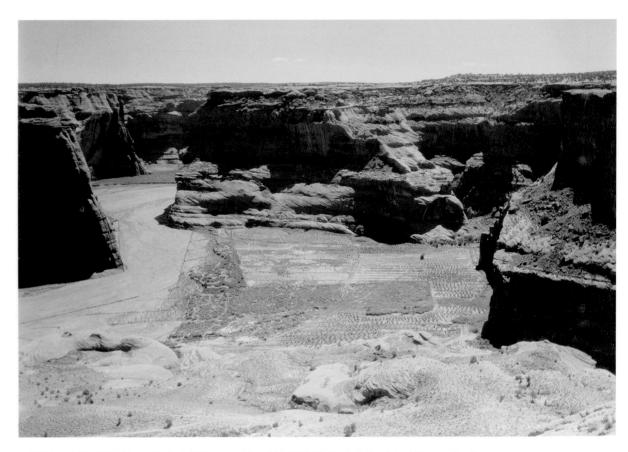

1936 Before visiting White House Overlook, Wallace spent the night at Chinle's Navajo Indian School. He meandered along Canyon de Chelly's South Rim Road—taking pictures, admiring scenery—then traveled to Fort Defiance, Shiprock, and Four Corners. Using the pleasure trip to pen a piece ("Canyons of Death") for *Arizona Highways* later that year (November 1936), Wallace admired the Navajo's "large bands of sheep" and noted that "they are becoming one of the finest Indian races in North America." AHS, PC180, Folder 1, #0240.

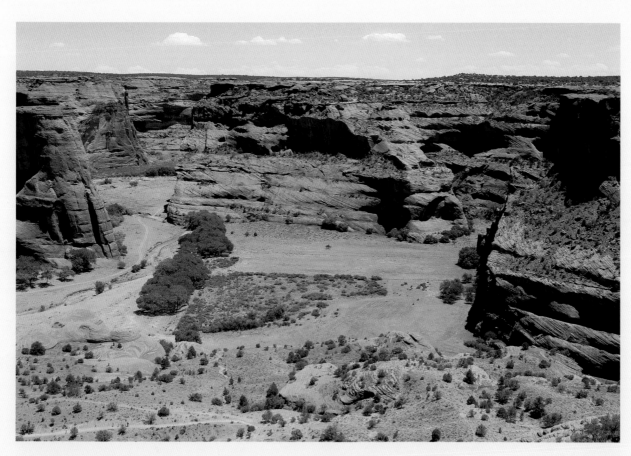

2018 Sharing Norman's fascination with history, I hiked into the canyon and admired White House Ruins (trail visible, lower left). Vegetation changes are dramatic: scrubby pines and junipers have broadly invaded nearby slopes; irrigated cornfields (Navajos still farm here) are less dominant; and native cottonwoods thrive (center left), replanted in a federal initiative to control erosion in the 1930s. Russian olive trees, also planted during the same era, surprised park managers and became a water-devouring pest. They have been mostly removed from this portion of the canyon. Author photograph.

MISSION SAN XAVIER DEL BAC

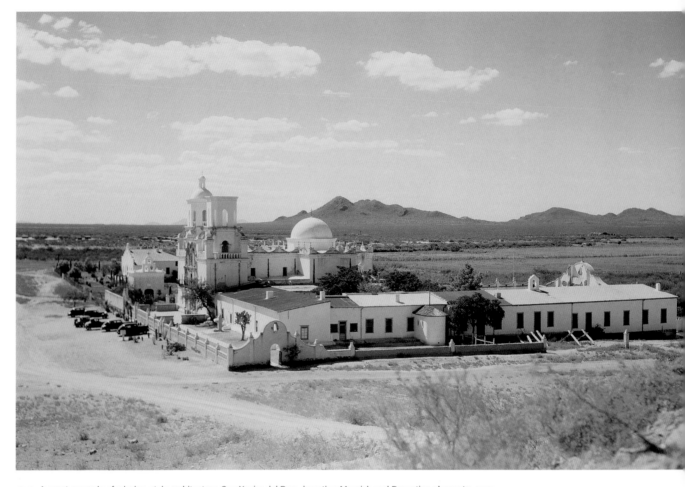

1941 A great example of mission-style architecture, San Xavier del Bac—boasting Moorish and Byzantine elements—was built by Spanish Franciscans between 1783 and 1797. By the early 1940s the mission building had been partially restored (in part with New Deal funding). The site was located on the San Xavier Indian Reservation south of Tucson. This classic view was taken from Grotto Hill east of the church. AHS, PC180, Box 41.

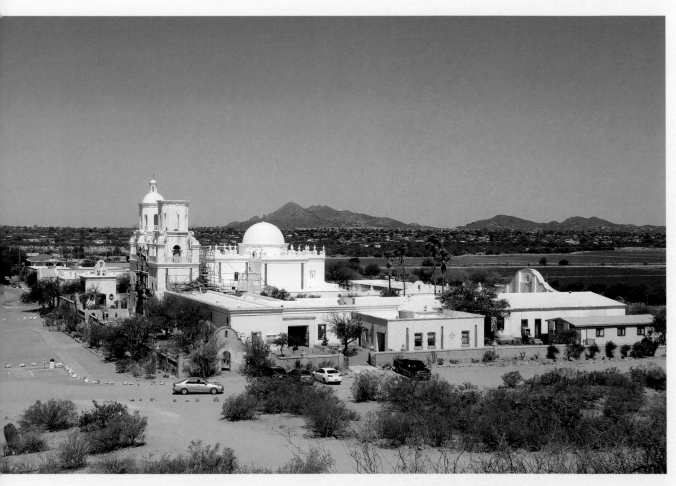

2016 Like Norman, I made repeated trips to the mission, perching on Grotto Hill. Restoration of the structure accelerated between 1949 and 1954, and scaffolding on the east tower reveals how the process continues today. Interior frescoes have been cleaned, and daily Catholic services are held. Nearby, Tohono O'odham residents offer food and souvenirs. Adjacent reservation lands (right) still yield irrigated pastures, but non-reservation acres beyond have sprouted suburbs instead. Author photograph.

1933 The San José de Tumacácori Mission—built by Franciscans—dates from the early nineteenth century, when southern Arizona was controlled by the Spanish (the region was known as Pimería Alta). Tumacácori became part of the United States in 1853 (in the Gadsden Purchase), and it was made a national monument in 1908. The roof was restored by 1921, and stabilization occurred during the 1930s. The parish priest's convento residence is also visible (right). Wallace visited the ruins numerous times, photographing the church, grounds, and restoration efforts. AHS, PC180, Folder 353, #761.

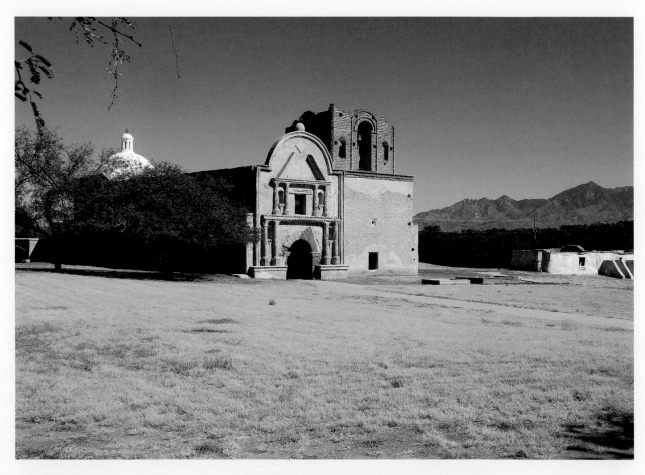

2016 Midmorning light filtered across the grounds. It smelled delicious. I was alone except for a woman making tortillas over a mesquite fire. She smiled as I paced around the courtyard. I leaned back and forth to line up the *espadaña*— the half-circle pediment on the front of the church—with the bell tower (never completed) behind it. Parts of the convento remained (right), along with the Santa Rita Mountains. It was a good day for an early lunch. Author photograph.

1934 This image also appeared in the October 1934 issue of *Arizona Highways*. Wallace's article ("The Trail of the Camels") reconstructed Lieutenant Edward Beale's wagon-road survey expedition—featuring two dozen African camels—across Arizona in 1857. Wallace delighted in rereading Beale's journals and following his route. Wallace notes, "Beale came through the pass shown in the center of the photograph and found water in a rocky pool in Chino Creek." AHS, PC180, Folder 341, #0023.

2017 Beale's expedition left a lasting impression. Both the Santa Fe Railroad and US 66 paralleled Beale's wagon road across the state. Some camels survived as well, and there were legends of feral humped beasts wandering the southwest deserts for decades. On my visit, Chino Wash was quiet with a few patches of green grass, but there were no rocky pools or camels. The view—taken from old US 66—looks northeast from the bridge. Author photograph.

circa 1936 Hi Jolly (a Syrian immigrant named Hadji Ali) served as a camel driver with Lieutenant Beale's expedition in 1857. He liked Arizona and lived there until he died in 1902. To honor Hi Jolly and the camels, the Arizona Highway Department produced a stone monument topped with a copper camel. In January 1936 Governor Benjamin Moeur dedicated Hi Jolly's resting place in Quartzsite. Wallace visited and photographed the quiet desert graveyard on the north side of town. AHS, PC180, Folder 342, #F.

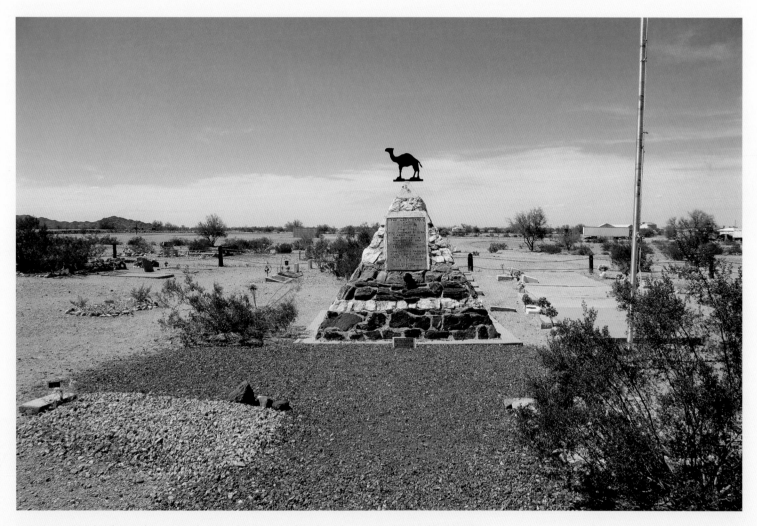

2017 Even cemeteries change: the grave markers have become more formal and the saguaros have vanished, but the creosote has flourished. The copper plaque and camel both possess a pleasing patina. Norman might have appreciated lyrics from "Hi Jolly, The Camel Driver" (New Christy Minstrels, 1962): "Old-timers out in Arizona / Tell you that it's true / You can see Hi Jolly's ghost a-travelin' still / When the desert moon is bright / He comes ridin' through the night / Leadin' four and twenty camels 'cross the hill." Author photograph.

MAKING HISTORY AT PIPE SPRINGS

1950 Winsor Castle's frontier ranching saga was the inspiration for Zane Grey's Withersteen Ranch in *Riders of the Purple Sage* (1912). Home to a Mormon ranching family, the fortified stone outpost (left) was built in the 1870s. Pipe Springs (left, beyond trees) provided water for settlers and cattle. Wallace visited on a trip in 1950 through the Arizona Strip. AHS, PC180, Folder 310, #G.

2018 A national monument since 1923, Pipe Springs features a visitor center and castle tours. While vegetation and outbuildings have evolved, the castle and the old east cabin (now a museum; right) reflected continuity. A newer corral dominates the yard, home to Texas Longhorns, pioneer cattle of choice. The corral clean-up crew let me slip in and replicate Norman's view. Author photograph.

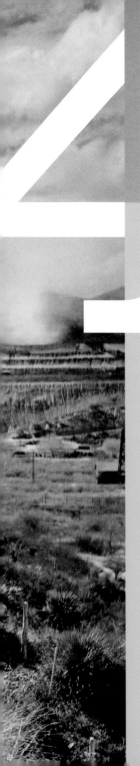

4

MINING'S
MARK

Begin with the Laramide orogeny, an era of mineral-rich (gold, silver, copper) mountain building that shaped Arizona between 35 and 80 million years ago. Add enormous infusions of money and technology that arrived between 1860 and 1940, the products of American capitalism and territorial expansion. This grand convergence of geology and economic investment sparked a remarkable mining boom and reworked everything in its path: it refashioned landscapes, despoiled physical geographies, built communities and fortunes, and shaped the lives of thousands of men and women. It was a stream of investments and events that shifted rapidly in its character from one decade to the next. Norman Wallace stepped into that stream when it was swollen with promise, in the ripe, heady days of early twentieth-century Arizona. He was fascinated by mining and drawn to its magical, transformative presence. The places, people, corporations, and unions still reverberate: Tombstone, Globe, William A. Clark, the Phelps Dodge Corporation, and the Western Federation of Miners were all part of Wallace's world, and they all remain indelible in Arizona's memory today.

opposite Miami Smelter (1944). AHS, PC180, Folder 243, #0165.

For Wallace, mining landscapes—the head-frames, tailings piles, processing mills, and rowdy towns—communicated a triumphal story of Arizona's conquest of the natural world. Norman's industrial aesthetic celebrated the visual expression of Arizona's mining economy: it was a story of hardworking people wresting a life from Arizona's rich underworld; it was a story of making wealth from the earth itself and in the process creating modern, prosperous communities. Wallace's heroic vision of mining is captured in the hundreds of images he created in mining districts and mining towns across the state. In *Arizona Highways* (December 1938) he describes for readers the experience of driving into the copper town of Miami. He writes, "You are riding Highway 60 and 70 bound for the place all travelers wish to see. A few miles from Globe the road turns and you see in the distance a glorious copper mining panorama. . . . There is red metal underground and there are miners with the knowledge, skill, and courage to mine it."

Wallace's early exposure to industrial mining came in northern Mexico. Much of his survey and construction work for the Southern Pacific Railroad of Mexico took him through important mining districts. In later years he photographed all of Arizona's major mining areas. Working on various highway projects, Wallace often lived in a nearby mining town—in a work camp or hotel—for weeks or months at a time. He knew Bisbee, Globe, Superior, Miami, and Clifton—all large centers of industrial copper mining—especially well, but he also visited smaller mining operations and settlements, photographing everything in sight. On his days off he might just as likely be taking pictures of smelter stacks and miner's cabins as he would be of saguaros and thunderheads. All of it was visually interesting to him. Wallace even caught the bug himself: for a while he owned an interest in the Morning Mine, located near Ruby in the southern portion of the state.

Ultimately, however, the main dividends Norman earned from mining were not financial, but artistic and personal. His photographs of Arizona mining settlements proved to be timely portraits of localities in the midst of change that led to even greater booms, but often even longer busts. Wallace realized how important mining was to Arizona and its visual landscape, and he stored and organized his "mining photos" together, making lists of the places he had photographed and how many times he had returned over time.

Now fast-forward seventy to one hundred years. Think about what has happened to the western mining industry. Many sites of mineral wealth have simply played out. Global competition has made marginal mines unprofitable. Other mines still in operation look radically different than in Wallace's time: huge machines and scaled-up technologies have replaced thousands of workers. Today the mining economy is all about big investments and giant pieces of equipment, not about workers and boisterous mining towns.

I revisited eight different mining landscapes that Norman had photographed. He took me to every corner of the state, from the Tom Reed mine near Kingman to the parched desert community of Ajo. We saw Bisbee again together, tucked high in mineral-rich hills not far from Mexico, and we sizzled on the streets of Globe, another legendary town with its copper-colored "G" on a nearby hill.

How does a mining landscape evolve? Two kinds of experiences marked my journeys with Norman to these settings. First, they made me think carefully about the material, visual consequences of abandonment. I traveled to Ruby, once the largest lead and zinc mining operation in Arizona. Norman visited the town in May

1929, two years after the Eagle-Picher Lead Company had bought the whole community. At one point Ruby—a great example of a company town—boasted a school, a hospital, and a population of more than 1,200 people. By 1940—after producing more than $7 million in ore—the place was already on the skids. Since then the town has exchanged hands several times. Today it is a privately owned, seldom-seen relic of another era. I was the only visitor there that day. Once I found Norman's photo location above town—it didn't take long—I wrote in my journal, "Utterly depopulated landscape, many mine houses gone, only ruins of milling facility, quietest place I can remember." I had similar experiences at the Tom Reed Mine in Oatman and at the Commonwealth Mine in Pearce: so much had vanished, been carted away, covered up, or left quietly just sitting there. On the other hand I also thought about what might still be there, less visibly, lurking in the soil or nearby groundwater. Often, mining's toxic legacy remains largely unseen.

The other experiences I had were more about adaptation, how mining towns reimagined themselves into something different. These are predictably fun, funky places: their built environments are quirky amalgams of past and present, an aging fundament of mining-era landscapes mingled with a newer veneer of tourism, perhaps a blossoming arts community or a sun-bronzed dash of Arizona retirement living. When I retraced Norman's steps to Bisbee, Ajo, and Jerome the mining scene was peppered with varying proportions of this newer mix. Often these post-metallic retrofits dated to the hippie era of the 1960s and 1970s, when a mix of low-cost housing and off-the-beaten-path charms attracted a new and eclectic generation of pioneers. I talked with jewelers and craftsmen, visited art cooperatives and local cafés, and was intrigued by how Norman's high-industrial, almost surreally austere images had been softened, made more complicated. The vibe had definitely shifted in the last eighty years: I sampled the food at the Bordello of Jerome, a New Age eatery that advertises "sexy food for carnivore and vegan alike, local art for sale, full bar." I don't know if Norman would approve, but such places are reminders of how the modern world has reworked some of Arizona's mineralized landscapes into more playful, postindustrial fare.

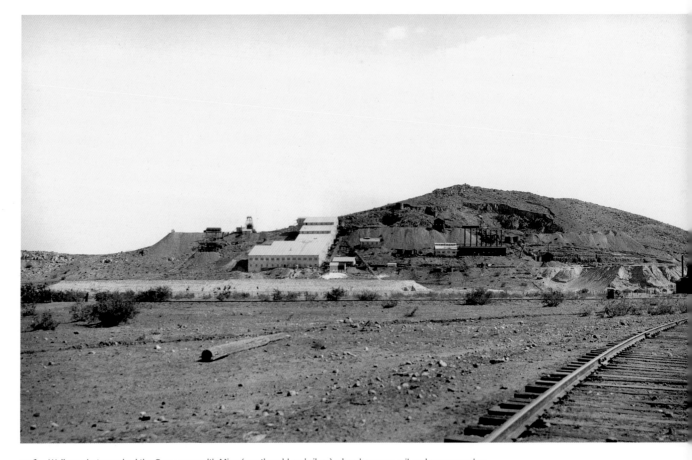

1918 Wallace photographed the Commonwealth Mine (mostly gold and silver) when he was a railroad survey worker in southeast Arizona. The mine was discovered in 1895 by James Pearce and had produced more than $20 million by World War I. Pearce (population 1,500) supported stores, a school, and a theater. The hill was also home to a large milling operation (center left), an onsite power plant (building with smokestacks; center right), and its own railroad spur line. AHS, PC180, Folder 350A, #0284.

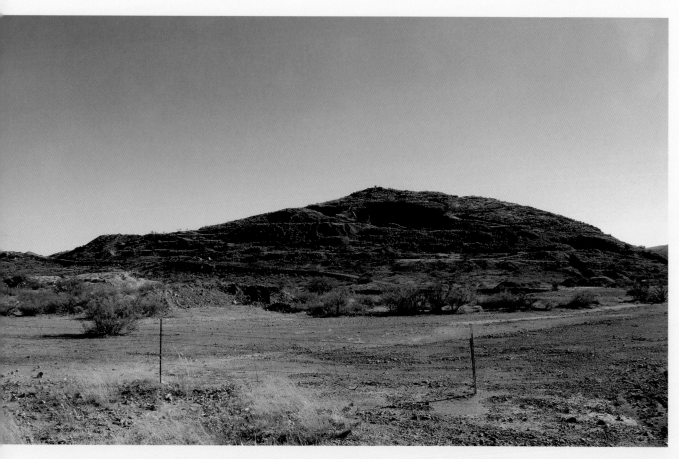

2016 I encountered a quieter place. The mine closed after 1930, and by 1935 state newspapers called Pearce "the most pathetic ghost town in Arizona." Beyond the pale of retirees and sun seekers, the tradition continues: today, Pearce's population is fifteen. Mesquite has colonized the mine hill, fenced to prevent casual wandering. I saw topographic signatures of the earlier operation, but most of the buildings and equipment had left the scene. Author photograph.

TOM REED GOLD MINE

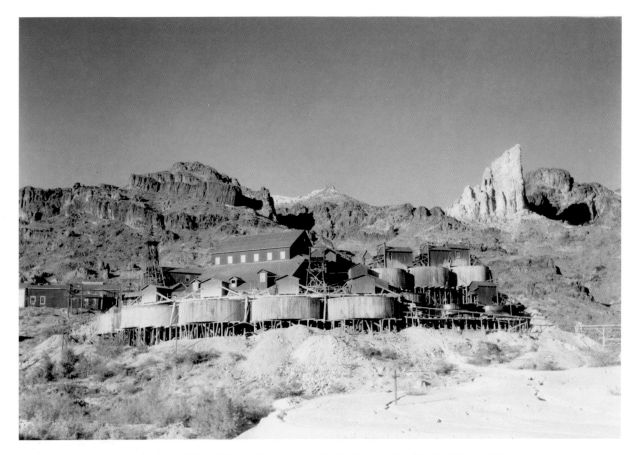

1934 Wallace lived in Kingman in 1934, working on US 66 and on the road to Boulder (Hoover) Dam. Weekend trips took him to the Tom Reed Gold Mine near Oatman. One of Arizona's richest gold mines, the mine was active between 1901 and 1939. This view includes (left to right) the head frame, the hoist/engine house, mill buildings, numerous water tanks, and tailings (far right). In geological parlance, the Elephant's Tooth (right) is a rhyolitic intrusion. AHS, PC180, Folder 350D, #0335.

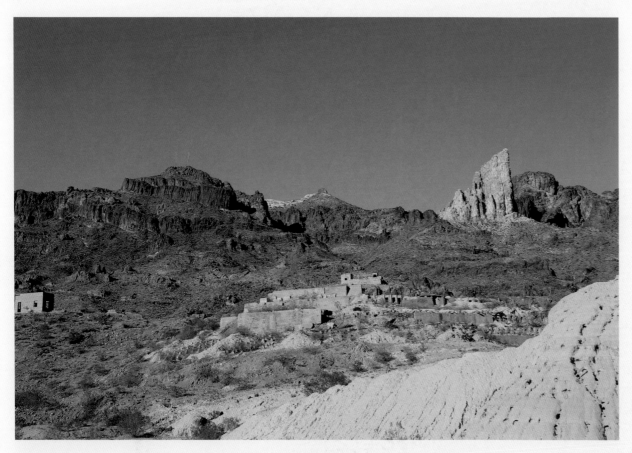

2016 Late afternoon temperatures hovered around 105 degrees as I pondered the view near Oatman. What had been
a largely humanized scene was now dominated by desert slopes and scattered creosote. At its peak, the twenty-stamp
mill employed one hundred men and processed 150 tons of ore daily. The large pile of mine tailings had grown (right), but
most of the mine's other landscape signatures had disappeared, carted away decades earlier. Author photograph.

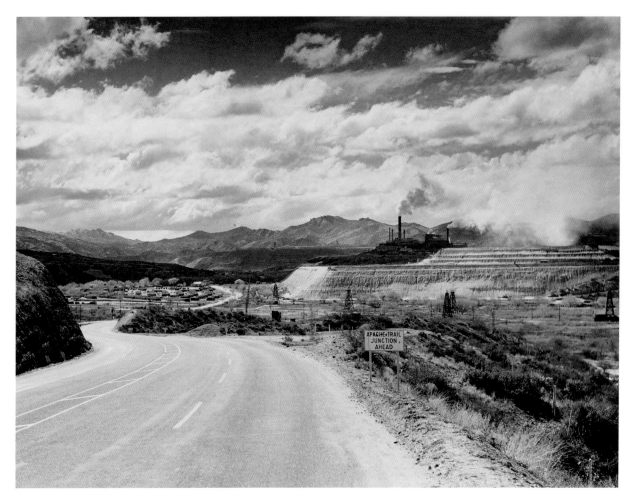

1944 Wallace's image celebrates the metallurgical magnificence of the Industrial Age. Wallace describes this wartime view of Miami: "There to the right is the tailing dam of the Inspiration Consolidated Copper Company; in the center clouds of smoke from the stacks of the International Smelter; to the left the mine plant and the tailing dam of the Miami Copper Company." AHS, PC180, Folder 243, #0165.

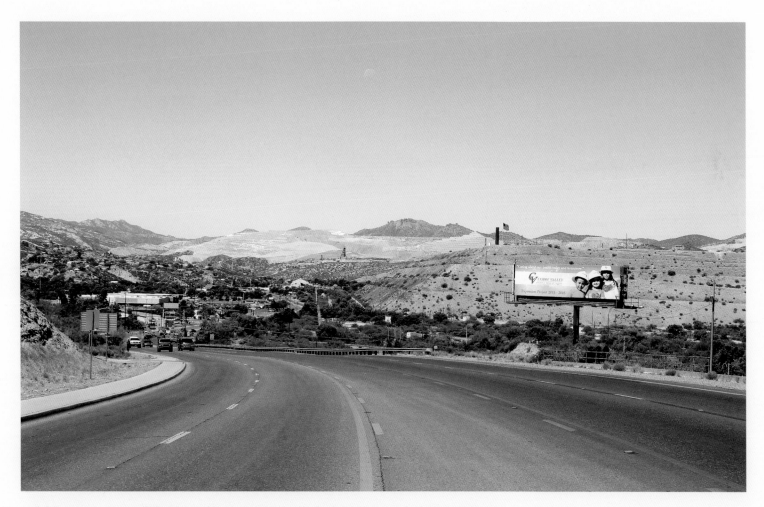

2016 "You trying to get yourself killed?" Horns blared as I dashed into the five-lane highway running between Globe and Miami. Regrettably, Norman's original position (with highway changes) sent me into oncoming traffic. Sharply engineered lines—symmetrical terraced terrains of earlier times—had softened, revegetated in some places (right), and had shoved skyward elsewhere (distance, left), reconfiguring the horizon. The billboard (right) and the sprawling Walmart (valley floor, lower left) were signs of post-industrial times. Author photograph.

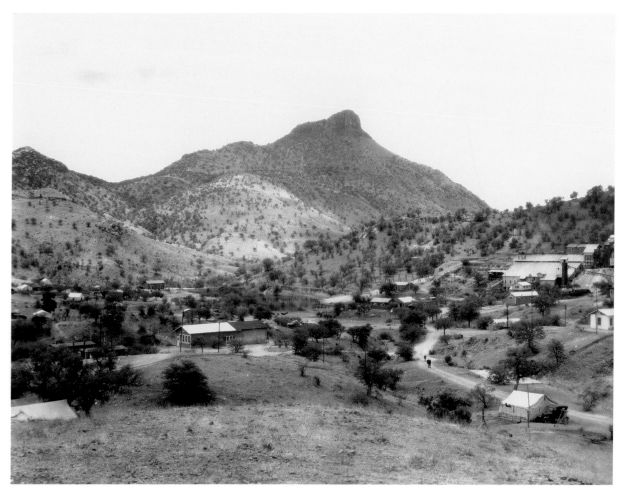

1929 Ruby was a company-owned (Eagle-Picher) lead/zinc mining town west of Nogales. Flourishing between 1926 and 1940, Ruby included 1,200 residents, a large commercial mine and mill (hill, right), a school (lower-center left), and various company-owned housing including tents, cabins, and bunkhouses. Before selling in 1941, the company extracted $10 million in ore, making it the state's largest lead/zinc mine operation. Wallace climbed a steep hill above the school for the photograph. AHS, PC180, Folder 350F, #717.

2016 The twenty miles of twisting unpaved road haven't changed much since Norman's time. I arrived in Ruby, the only visitor. The caretaker (white house, far right) pointed me toward Norman's hilltop view. Several families own Ruby, and they work to preserve it. The mill and most houses are gone. Miners have been replaced by mesquite. School buildings, a rust-toned Ford truck (lower right), and 700,000 tons of mine tailings (distance, left) still call Ruby home. Author photograph.

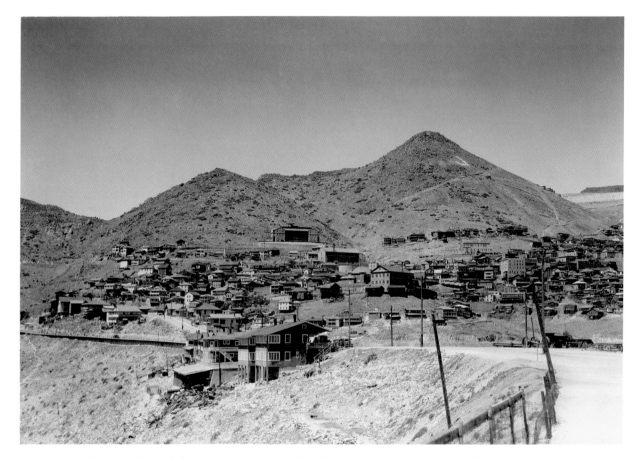

1933 Jerome ranks as one of the West's richest mining towns. Population peaked at fifteen thousand during World War I. Montana copper king William Clark purchased the United Verde Mine beneath Cleopatra Hill in 1888, and mine assets were sold in 1935 to the Phelps Dodge Corporation. When mining ceased in 1953, more than $375 million in copper, gold, and silver ore had been extracted. In Wallace's view, the imposing company-owned hospital, opened in 1927, is visible (center left) with the Clark Street School nearby. AHS, PC180, Folder 238, #0243.

2016 Despite steep odds—and equally steep hillsides—Jerome has survived. After the mines closed, less than fifty people remained in the town. Hippies, artists, and outdoor enthusiasts trickled in during the 1970s, enjoying Jerome's funky vibe of bawdy history and spectacular scenery. I struggled to find Norman's roadside perch, now in the Art Center's parking lot. The hillside "J" still reigns, the Hospital is now the Grand Hotel, and the Clark Street School is the City Hall and Library. Author photograph.

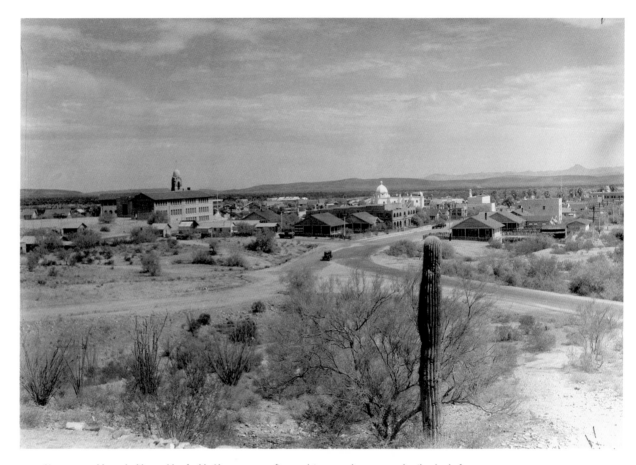

1933 Norman was blessed with sunshine for his Ajo panorama after sandstorms and monsoon rains the day before.
Following a night of sleeping in his car, he found a favored spot west of town, noting "view from Hospital good" in his
log books. Ajo had 3,300 residents in 1933. The New Cornelia Copper Company (later the Phelps Dodge Corporation)
supported Ajo as a planned town with a central plaza, a school, a hospital, housing, and a water and sewage system.
AHS, PC180, Folder 215, #2628.

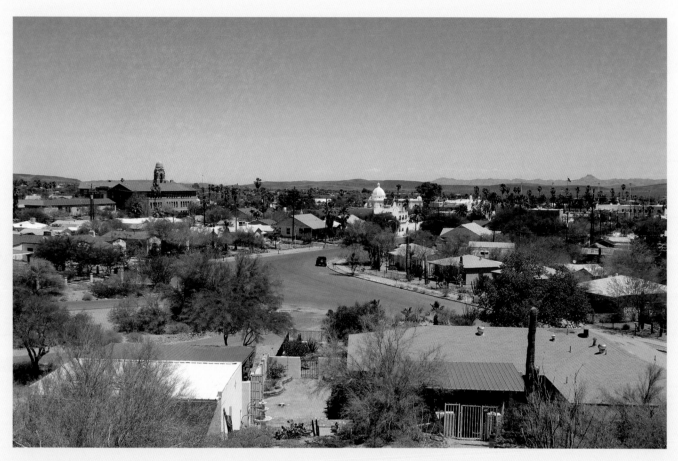

2017 I recognized several company-era buildings from Hospital Hill. While mining ceased in 1985, Ajo has about the same number of residents as it did in Norman's time. An eclectic mix of retirees, seasonal snowbirds, artists, and Border Patrol agents keep Ajo vibrant. The renovated Curley School (left) houses stylish apartments, a community center, and art studios, and the Immaculate Conception Catholic Church (dome, center right) survives. I enjoyed my midday walk to the palm-bordered plaza (distance, right, near flagpole). Author photograph.

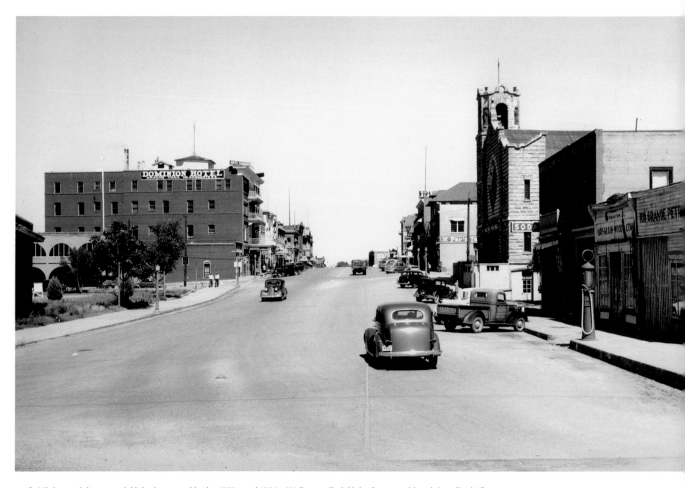

1938 Mining activity around Globe increased in the 1870s and 1880s. Wallace called Globe "a venerable mining district"
by the late 1930s. He spent much of 1938 working in the vicinity of Globe. His Broad Street view looks west and includes
the Rio Grande Service Station, the Upton Building, and the Holy Angels Catholic Church (right) as well as the impressive
eighty-room Dominion Hotel, built in 1907 (left). AHS, PC180, Folder 234, #0024–8.

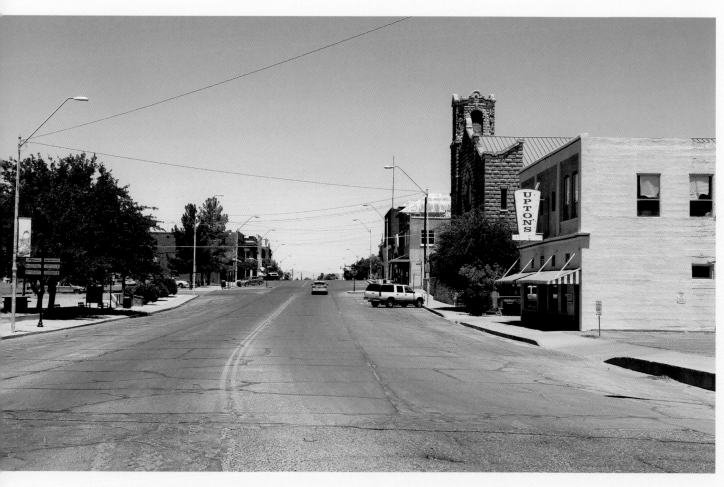

2016 Globe now enjoys a slower, deindustrialized pace. The gas pumps are gone, but the Upton Building features a storefront church downstairs and apartments upstairs. Stone-faced Holy Angels Church has persevered and remains active today. A smoldering mattress of suspicious origin sparked the downfall of the Dominion Hotel in 1981. On the block today, I found a wellness center, an acupuncture therapist, and Copper Communities Hospice. Author photograph.

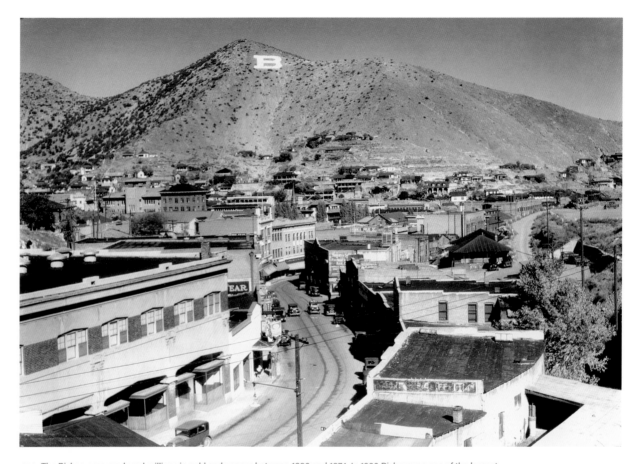

1933 The Bisbee area produced millions in gold and copper between 1880 and 1974. In 1930 Bisbee was one of the largest cities between New Orleans and Los Angeles, with the town boasting more than fifteen thousand residents. During that era, Norman and Henrietta briefly lived in Bisbee "in a little house on the hill." This photograph down Tombstone Canyon shows Main Street (center). The Masonic Temple (far left) dominates the view, and the Elks Lodge and Odd Fellows Hall are down the block. The ambulance, chapel, and undertaker serendipitously share the block's south side. AHS, PC180, Folder 219, #2041.

2016 Challenges greeted me on the hill: bushes and trees blocked my view. Finally I compromised with a utility pole and captured a similar Main Street view. Like Jerome, Bisbee has reimagined itself into a cool and artsy place beyond the life of the mines. I visited with painters, sculptors, jewelers, musicians, and retirees. Both the Masonic Temple and the hillside "B" survive amid increased tree cover on the slopes. Author photograph.

5

SMALL TOWNS

Norman Wallace spent a great deal of time living in Arizona's small towns. He would often set up a temporary headquarters at a local hotel in a place such as Globe, St. Johns, or Kingman, and then he would live there for several months while working on a particular highway survey and construction job. He also improved the highways that defined small-town Main Streets and that connected them with the outside world. Norman's small-town photographs reflected the conventions of the day: his post-card-style views typically captured Main Street scenes or featured prominent buildings such as key businesses, schools, or government offices.

opposite St. Johns (1937). AHS, PC180, Folder 252, #0084.

Arizona's small-town landscapes—both in Norman's time and today—reflect larger cultural themes. As I wandered in his footsteps, I was reminded of all the symbols of small-town stability and identity captured in such places. Geographer Donald Meinig called this generic "Main Street" scene one of the great symbolic landscapes of American life. He notes, "Main Street is the seat of a business culture of property-minded, law-abiding citizens devoted to 'free enterprise' and 'social morality,' a community of sober, sensible, practical people."

Meinig's words rang true as I stared down Safford's Main Street, finding Norman's stand-in-the-middle-of-the-road prospect, looking west. Straight ahead was the Graham County Courthouse, facing east onto a public square. The stately, two-story neoclassical building, built in 1916, has been the seat of local government for more than a century. Less than a block away, on the south side of the street, I identified the Greek Revival columns of the historic Arizona Bank and Trust Company Building, constructed in 1920. On the National Register of Historic Places since 1982, the impressive stone structure celebrates the role played by local financial institutions in places such as Safford. Above all, Safford's small-town Main Street is dominated by *business*, both in 1933 and in 2016. Commerce and the conservative values of small-town life were reflected in Norman's view of Main Street and my own.

As I became better acquainted with Arizona's small towns, I was struck by the strong local attachments to place rooted in the memories of long-time residents. These memories are richly layered over several generations, woven into the fabric of the landscape itself—particular buildings, streets, and neighborhoods—and animated with stories that are grounded in everyday experiences lived in these places. There is a possessive pride in these localities, often a shared ambivalence about change, always a place

identity based in family history. I loved meeting older people in these localities, showing them Wallace's image from seventy or eighty years ago, and then listening to them fill in the delicious details that enlivened their recollections about life there. Often their memories almost reached back to the day decades earlier when Norman was in town with his camera and tripod.

In the tiny town of Congress Junction northwest of Phoenix, I met Dan Jacobs, whose family had arrived in 1955, only six years after Norman had recorded his fine Main Street scene. Dan's family opened the nearby Arrowhead Bar and put down roots in the place. Sitting in Dan's office out back of the house, we went building by building in Wallace's image. Every structure had a story: the evolution of the Texaco station, the nearby tourist cabins that had once served as a brothel, the 102-year-old building down by the Shell station with its great gun collection in the basement. As Congress Junction's unofficial historian, Dan pulled out newspaper clippings and other fragments of the town's past, his mind a rich, fragile record of how lives and landscapes have changed over time.

On the other end of the state, I met Lawson Nielson, whose family had lived in St. Johns, a small, mostly Mormon farm town, for several generations. Owners of Nielson Well Drilling Company today, Lawson told me about the building's history and its earlier life as a mercantile business. We talked about the famed Barth Hotel, once located across the street but now home to a patch of green grass and a small gazebo owned by the Catholic Church. In the late nineteenth century, the Barth family controlled a legendary sheep and cattle ranching operation that sprawled across eastern Arizona. Their livestock empire helped build St. Johns, and Lawson knew how many of the structures in town—both surviving and destroyed—had been related to their fortune. In the 1930s Wallace

befriended Jacob Barth, who was also an Arizona State Highway Commissioner. As Wallace notes in his log books, Barth—a collector of Native American art—invited Norman to photograph his collection of Hopi and Navajo artifacts in his hotel and home. I enjoyed connecting Norman's experiences in St. Johns with Lawson's own stories about the town and the Barth family.

All of Wallace's views offered the chance to see how landscape change actually takes place in small towns. As I peered through the camera lens in various places, some buildings had obviously survived, often in modernized form, while others had vanished or had been replaced with entirely new structures. I was struck by how unpredictable and serendipitous it all was. We often generalize about landscape change in a place (like Main Street) as a "process" that unfolds over long periods of time, but I came to see the story more as a series of events driven by incremental shifts at particular points in time: a fire destroys a corner building; a café owner retires, and the business becomes a barbershop; or a gas station closes because of a changing corporate strategy.

I enjoyed collecting particular tales of landscape change. In tiny Hillside (not far from Prescott), luck was with me because I arrived only days before the town's old grocery and liquor store—which Norman had photographed in 1949—was to be torn down. I met Kelly—the building's current owner—who was keen to knock down the old frame structure and put up a more modern commercial building. Inside, Tony and Chris were busy taking out walls, hauling away anything useful. You could still see remnants of the post office in the back and the ice-cream freezers that once held precious popsicles. I thought about how different my picture would look in just a few weeks.

Elsewhere I looked at more subtle, nuanced changes in the small-town scene: signs had changed, roof lines were modified, storefronts had been updated, or once-busy business blocks were now half vacant. Sedona, a tiny farm town in Wallace's day, witnessed the greatest transformation. The town, near famed Oak Creek Canyon, now supports resorts, golf courses, and upscale shopping centers. Norman's original photo point, a hill above Dad Hart's Grocery Store in 1939, was now on the driveway up to a Hyatt Hotel. Nearby farms and fruit orchards were now home to art galleries, ATV rental outlets, New Age crystal shops, and trendy cafés. The traffic circle below me—on the site of Dad Hart's place—teemed with traffic. I thought about how Norman would probably approve of the traffic circle's simple, elegant design but look with disbelief on how this small town had changed.

1933 Wallace visited Cameron on his way to camp at Grand Canyon. His view looks north toward the suspension bridge, erected in 1911, across the Little Colorado River. The small settlement on the Navajo Reservation was originally called Mabel's Oasis. The large stone structure (center left) was a small hotel. A small two-pump gas station sat out front with a decorative Navajo hogan nearby. The light-toned structure (left) housed a post office, a soda fountain, and a trading post. AHS, PC180, Folder 163, #A.

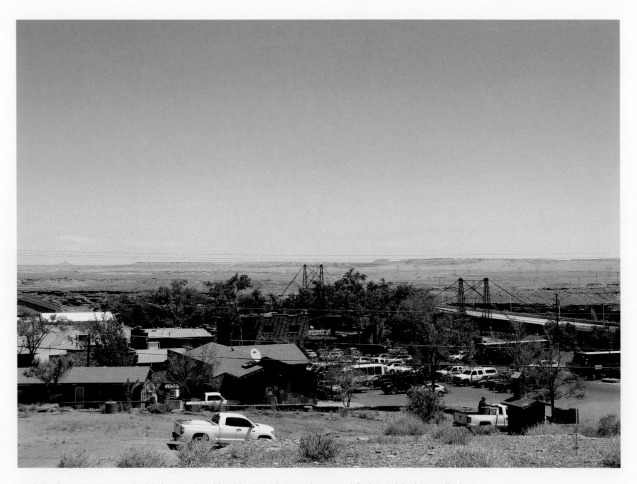

2016 Trading-post manager Carl Colson spoke with pride about Cameron's centennial when I visited. He walked me through the details of Wallace's photograph. The parking lot bustled with cars and tour buses. I climbed the hill to Norman's view in triple-digit heat. The hotel has expanded and includes a lovely central garden and patio (in the trees behind the stone building). Additional structures support the store, the restaurant, and the lodging operation. The newer bridge dates from 1959. Author photograph.

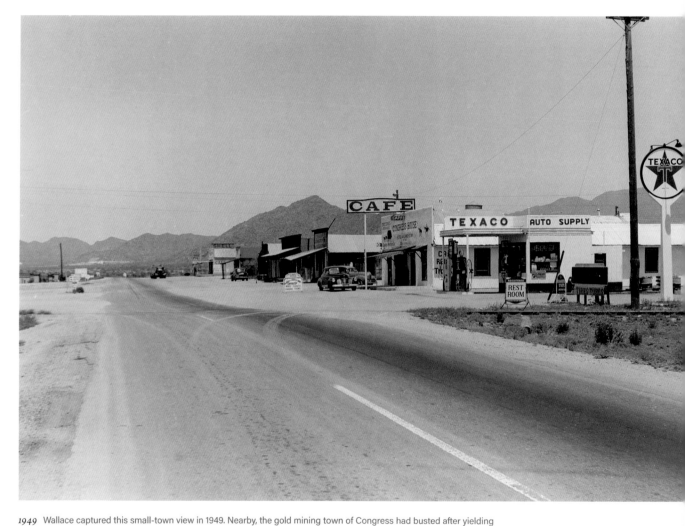

1949 Wallace captured this small-town view in 1949. Nearby, the gold mining town of Congress had busted after yielding millions in bullion between 1883 and 1935. But Congress Junction boasted a rail-shipping point for sheep and cattle, and it sat on a major highway junction. Travelers filled their gas tanks and enjoyed a meal at the Congress House café before heading to Prescott or Phoenix. AHS, PC180, Folder 227, #0365–7.

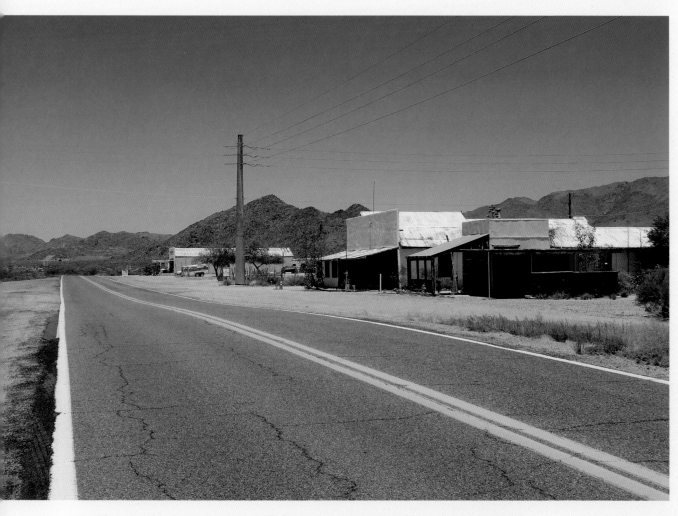

2016 While nearby Wickenburg hummed with activity, it was easy to stroll across the highway in Congress Junction.
Most through traffic bypasses the town, running several miles west on the main road between Phoenix and Las Vegas
(US 93). Some buildings had been removed while others sat shuttered in the midday sun. Author photograph.

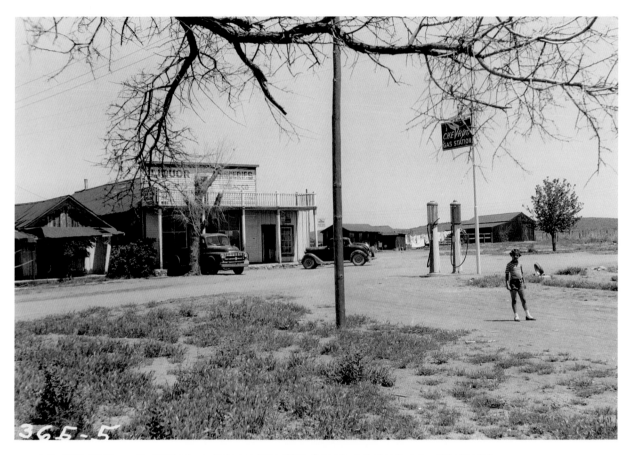

1949 In the 1940s Hillside—north of Wickenburg—had a population of forty-five and was the headquarters of the Bagdad Copper Company. It was home to a hotel, a gas station, and a general store (pictured). Wallace paused long enough to photograph the Chevron service-station pumps, the store, and a girl who helped frame the scene. AHS, PC180, Folder 235, #0365–5.

2016 I guessed the girl would be about seventy-five years old. I asked a few folks—including the owner of the Hillside Country Store, which closed in 2010—if Wallace's image or the girl rang any bells. No recollections, but it was still my lucky day: the Chevron pole stood tall, and the building across the street had survived. I walked through the empty structure. It was being gutted inside, destined to be rubble within a few weeks. Author photograph.

EXPLORING TORTILLA FLAT

1927 Tortilla Flat was established in 1903 during the construction of the Roosevelt Dam (completed in 1911), an early federal reclamation project along the Salt River east of Phoenix. The road to the dam (the Apache Trail) became a popular tourist route, and Tortilla Flat was a stop along the way, offering cabins, food, and fuel. Wallace's image looks south and includes the tourist services along Tortilla Creek. Note the large creek-side trees (right) behind the cabins. AHS, PC180, Folder 304, #0601.

2017 Wallace would still recognize the Apache Trail: it remains a narrow, twisting highway, though it is now paved.

The scene at Tortilla Flat has changed: a monsoon-season flash flood in the early 1940s swept away creek-side structures

and many large trees. The tourist stop was rebuilt east of the highway, and my view captured the parking lot and a forest

of mesquite. Today's population is six, making Tortilla Flat Arizona's smallest official community. Author photograph.

1936 Fort Defiance was established in 1851 to assert US Army control over the Navajos. After 1870 it became home to federal Indian Agency offices and services. Wallace climbed a steep, rocky hill and took this midmorning image, looking west. Our Lady of the Blessed Sacrament Catholic Church (built in 1915, left), various houses, a trading post (at the bottom of the hill), Indian Agency offices, and an Indian hospital (right) are visible. AHS, PC180, Folder 231, #0266.

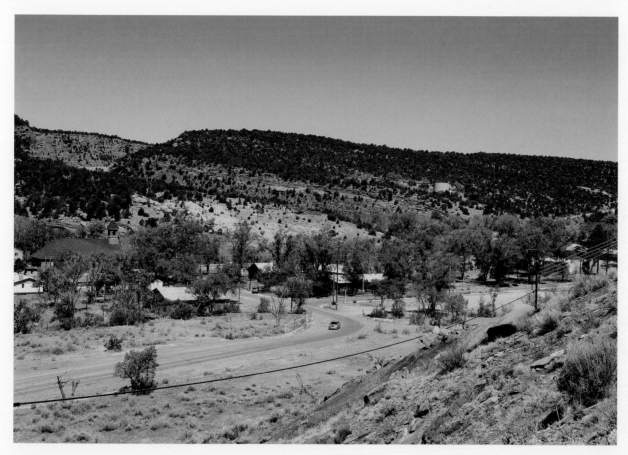

2018 I scrambled across the hill below the water tower, finding Norman's spot among the rocks, old bottles, and beer cans. My view contained more trees but fewer structures. A resident I met at the Catholic Church enjoyed Norman's photograph, noting how many buildings had vanished. Fort Defiance has 3,500 residents, and over 90 percent are Navajo. Author photograph.

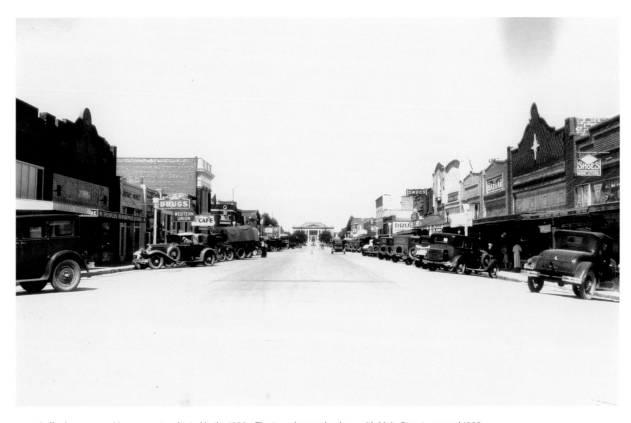

1933 Safford possesses Mormon roots, planted in the 1880s. The town boomed—along with Main Street—around 1900 with the completion of the Gila Valley, Globe and Northern Railroad. Irrigated crops did well here, including cotton. Wallace took this picture looking west down Main Street. The Neoclassic Graham County Courthouse is straight ahead, and the handsome columns of the Gila Valley Bank are visible down the block (left). AHS, PC180, Folder 252, #2304.

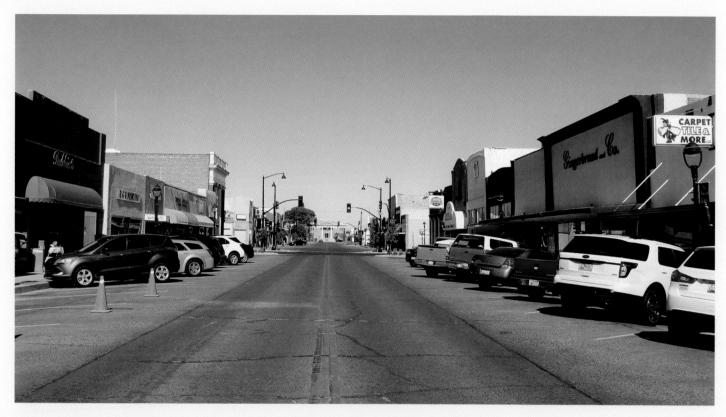

2016 I replicated Norman's busy morning scene. Local shoppers still patronize downtown, but much of Safford's retailing has moved to nearby US 70, where motels, chain stores, and strip malls outpace quieter Main Street businesses. Still, people arrived to shop, much as they did eighty-three years earlier: the former shoe store was hawking carpet and tiles (right), and the Safford Theater down the street had switched from showcasing King Kong to La La Land. Author photograph.

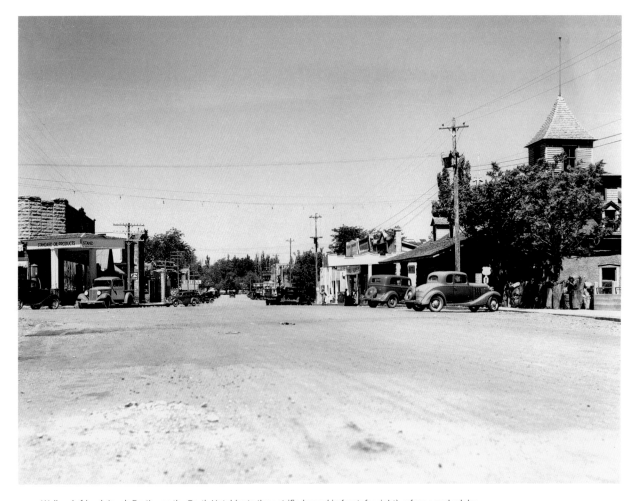

1937 Wallace's friend, Jacob Barth, ran the Barth Hotel (note the petrified wood in front; far right), a frame and adobe building that anchored the community. Barth displayed his museum-quality collection of Native American rugs, pots, jewelry, and artifacts in the lobby. The Barth Mercantile was next door. The Barths—pioneer sheep ranchers—founded St. Johns in the 1870s and attracted both Hispanos from New Mexico and Mormons from Utah. A Standard Station (left) and the Apache Café were located across the street. AHS, PC180, Folder 252, #0084.

2017 Today St. Johns (population 3,500) still includes families tracing their roots to Hispanic and Mormon pioneers. My midweek visit found downtown quiet. I grabbed coffee at the Village Café (down the block, left) and chatted with the Nielsens on the corner, whose family had owned the building for several generations. The grassy lawn and gazebo— now Catholic Church property—has replaced the Barth Hotel (right), and the Mercantile is a Church-owned social hall. Author photograph.

circa 1939 Nearby Oak Creek Canyon enchanted Norman Wallace. He loved spending time there to photograph its red-rock scenery. He put it on the cover of *Arizona Highways* and knew its colorful sandstone outcrops well. Sedona was a tiny farm town near the entrance of the canyon, and most residents raised livestock and fruit trees on small creek-side parcels (distance, center). Wallace climbed a juniper-studded hill to photograph Dad Hart's (second) store, located at the highway junction. AHS, PC180, Box 40.

2017 When is a small town no longer small? Sedona passes the test. The population has swollen from one hundred to over ten thousand. Wallace's view now includes one of Sedona's many traffic circles (installed in 2008), engineered to cope with soaring weekend visitation. Businesses offer Kundalini yoga, New Age crystals, pink jeep tours, and pizza bistros. Mexican-themed Tlaquepaque Village sits in trees beyond the circle (distance, center). I stood in the driveway at Hyatt's Piñon Pointe Resort to replicate Norman's view. Author photograph.

6

MOTHER
ROAD

Norman Wallace loved Highway 66. He was drawn to the history and national importance the road assumed during the 1930s and 1940s. He took pride in his own role in improving the highway during that same era: he straightened it, realigned it, and paved it, making much of the route faster and safer. He also loved the visual aesthetics of the highway and its elegiac path across northern Arizona. For Wallace the alternating procession of towns and changing western vistas formed a visual simulacrum of all he loved about the West.

A few particulars about the Mother Road and its rise from dusty byway to national thorough-fare: US 66 was christened in 1926, part of a federal highway numbering system designed to simplify maps and way-finding in the increasingly transcontinental world of automobile travel. The early route was primitive: in 1930 the four hundred dusty miles across Arizona took fourteen hours of hard driving, and it was a mostly unpaved trek. The road gathered fame by

1932, heralded as the "Main Street of America" and promoted as the best way to drive out west to the Olympic Games in Los Angeles. But it was the more painful westering saga of Dust Bowl migrants that secured the route's notoriety as the "Mother Road." Captured in 1939 by John Steinbeck's *Grapes of Wrath* and by John Ford's film by the same name, the highway—paved after 1937—fully emerged as America's national boulevard west. Bobby and Cynthia Troup's

opposite Concrete Byway (1940). AHS, PC180, Folder 65, #79–1.

"Get Your Kicks on Route 66!" added icing on the cake in 1946. No wonder US 66 remains the nation's most celebrated, nostalgia-filled highway.

Wallace enters the story in 1932. He cut his teeth on US 66: he began his Highway Department career with work along the route near Flagstaff. Over the next eight years, he was a prime player in modernizing US 66, spending weeks along the road from the Navajo Reservation in the east to Peach Springs and Kingman in the west. Wallace was fascinated with the route's history, how it paralleled Lieutenant Beale's fabled camel expedition in 1857 and the construction of the Santa Fe railroad line in 1884. When editors of *Arizona Highways* decided to feature the highway in their May 1955 issue ("Arizona 66, The Scenic Wonderland Highway"), it is no surprise they turned to Norman to write the piece.

Wallace takes his readers from the New Mexico line to California. Don't expect a landscape of crops and farmsteads, Wallace notes, suggesting "most of the terrain will be of the 'wide open spaces' type." Entering the state near Lupton, Wallace describes how the highway crosses a corner of Indian Country and how the traveler will see "Navajo Indians riding horseback" and "many Navajo hogans, or houses, scattered along the adjacent terrain." Then we're on to the surreal stone logs of the Petrified Forest and the chromatic colors of the Painted Desert as the route swings west through Holbrook ("a city of several thousand people") and Winslow ("mostly a railroad town"). Treeless plateaus and plains give way to pine forests in what Wallace calls the "finest part" of the route as US 66 climbs toward Flagstaff and Williams with "many vistas of the snow-capped San Francisco Peaks between the green trees." After summiting above 7,000 feet, the road descends toward the California border and the funereal heat of the Colorado River Valley. En route, Wallace describes the "low juniper-covered ridges and wide grassy valleys" near Seligman, the "vastness of the desert regions of western Arizona," and finally the "long steel bridge crossing the river" near Topock and the California line.

My own experiences along Arizona's 66 began at age six on a cross-country family trip between California and Oklahoma. In the back seat next to my grandmother, staring out the window, I have blurred recollections of a 1961 Buick speeding across the state (my grandfather had a legendary heavy foot). I remember the approach into Flagstaff, horizons filled with thunderheads, and the visceral thrills of swiftly passing slow-moving cars and trucks. To keep busy (my grandmother's idea), I penciled down the name of every town we passed through, trying as well to record its population and elevation.

Let a half century pass, and I'm back on that same highway with Norman. It was a memorable week. I had a stack of his Mother Road images in the back seat: he took hundreds of photographs—both for work and pleasure—along the route, and it was difficult to choose which ones worked best until I made comparisons in the field. Given the popularity of US 66 and the nostalgia for the road, I had a good idea where previous alignments of the road existed, but it still involved some hunting, especially to repeat photographs Wallace had taken along portions of 66 that were bypassed multiple times by newer routes.

For example, more than eighty-five years had passed since Wallace had taken a picture "west of Lupton" on a slice of the Navajo Reservation. I figured he was north of the current interstate. I wanted to find the spot because it captured the open, unbounded character of eastern Arizona's plateau country with its expansive skies and sparse juniper-covered landscapes. Back and forth I drove along an old, roughly paved road, trying to line up the right assemblage of rock outcrops. Pickup trucks, bursting with curious Navajo kids and barking dogs, sped by as I paced along the road

in the afternoon heat. My patience was finally rewarded, and I saw the scene come together. With Interstate 40 roaring in the distance, I had a great US 66 moment as I took the image from Norman's spot, knowing I had found one of the uncelebrated but surviving stretches of the Mother Road.

My stop in Flagstaff took me to a stretch of highway once crowded with tire shops, gas stations, and the Santa Fe Railroad Station, completed in 1926. Today the station remains, but much has changed. Wicked Coffee and Flagstaff Pawn occupy a nearby corner in my view, and Randy's Downtown Garage marks the former Texaco Station. The guys at the garage all stopped work to crowd around and peer at my vintage photograph, then they showed me the old Texaco sign still hanging in the office and asked me to send them a copy of the image.

My favorite encounter with Norman along US 66 was a visit to Sitgreaves Pass on the state's western edge. It was a long-bypassed stretch of highway that snaked over the Black Mountains near the gold-mining town of Oatman. Hairpin turns, steep grades, and spectacular desert vistas still make this portion of old US 66 a favorite segment for those seeking a dose of western highway nostalgia. Norman's view in 1933 looks east toward Thimble Butte and the Hualapai Mountains. I scrambled up a nearby hill, found his spot, and waited for afternoon shadows to lengthen. Finally my moment arrived, but I needed one critical addition: Norman's view had captured an automobile laboring up the steep hill. I waited, then I waited some more. Finally a white sedan popped around the turn, and my work was done. It was the end of a perfect day.

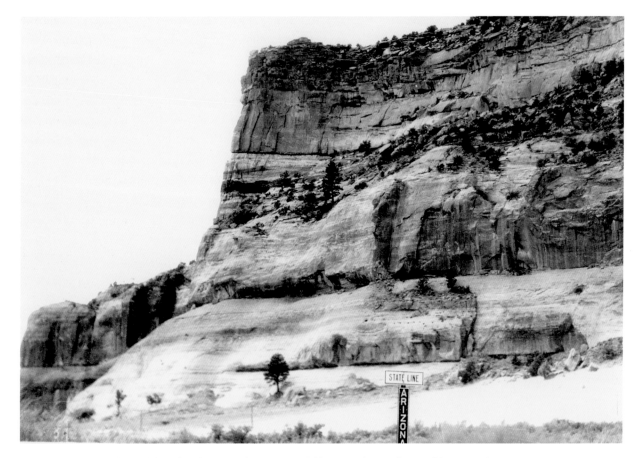

1933 Wallace spent five days cruising Arizona's Route 66 in August 1933. Taking many pictures, the expedition was a mix of "art" and "state" work. Starting at Topock on the Colorado River, he traveled east, stopped an extra day at the Grand Canyon, then ventured to the New Mexico line before turning around. This state-line view looks west toward sandstone bluffs north of the highway. AHS, PC180, Folder 68, #A.

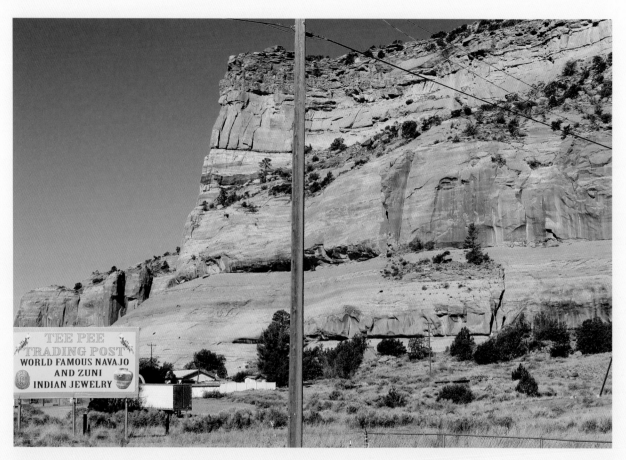

2018 I pulled off Interstate 40 to capture Norman's scene along the old highway. It was still a busy place: Speedy's Truck Stop sat partly in Arizona, partly in New Mexico (off camera, right), and there was a steady stream of big-rig action that kept me alert to traffic. The sign for the Tee Pee Trading Post advertised a large gift store full of Southwest souvenirs all housed in a huge teepee (off camera, left). Author photograph.

1933 The image captures eastern Arizona's vast open spaces. This stretch of highway—still unpaved in the early 1930s—crosses a narrow corner of the Navajo Indian Reservation. A couple of structures are (barely) visible south of the road (distance, right). Scattered junipers offer contrast in the landscape, but not much shade. AHS, PC180, Folder 68, #A-135.

2016 This unmarked stretch of historic US 66 west of Lupton—now a ribbon of worn asphalt—no longer plays host to the Joads, long-haul truckers, or transcontinental travelers. It gets local use and connects the nearby interstate (distance, center) with small Navajo communities north of the highway. The freeway traffic, utility poles, and small power station (far left) offer more human presence than in Norman's day. The junipers still offer little shade, but they have thickened in coverage. Author photograph.

1943 Seventy miles west of the state line, Holbrook was home to about 1,200 residents. This wartime view looks south and west along US 66. A stock-raising and railroad center (the Santa Fe line runs east to west at the south edge of town), Holbrook was also home to an array of auto courts, hotels, and gas stations. The cemetery (left) welcomes travelers, and the Navajo County Courthouse (near center) dominates downtown. AHS, PC180, Folder 236, #0070.

2016 Perched on a steep, reengineered slope between Interstate 40 and an off-ramp into town, I easily found the maturing cemetery (left) and historical courthouse (now a county museum). Holbrook—a busy community of five thousand residents—caters to commercial interstate traffic and to nostalgia seekers driving old US 66. The famed Wigwam Motel ("sleep in a teepee") remains a prime attraction (not visible) in addition to the more prosaic pleasures offered by the Dairy Queen (right). Author photograph.

1941 Wallace was traveling to Petrified Forest National Monument when he stopped in Winslow. Town boosters boasted
about its seven thousand residents, the airport's new TWA terminal, and its role as the "Metropolis of the Southwest
Indian Country." Indeed, Norman's busy view along US 66 (looking east) has a metropolitan feel to it: a parade of cars
in downtown traffic, people strolling the sidewalks, and a bevy of cafes and stores offering curios, furniture, and cold
Budweiser. AHS, PC180, Folder 270, #0207–6.

2016 Winslow survives, but the town has lost its big-city vibe. Tourists still flock there to enjoy US 66 nostalgia; to see the lovely La Posada, a restored trackside railroad hotel; and to admire Standin' on the Corner Park celebrating a locally set 1970s-era song ("Take It Easy") by Jackson Brown and Glenn Frey. The J. C. Penney and Winslow Drug block is razed, but the tan brick building across the street (left) and the Rexall Building (right) remain. Author photograph.

circa 1938 Wallace lived in Flagstaff multiple times, continuing to improve and reroute US 66. He enjoyed the area's forests and high-country scenery. This pre–World War II view looks west and reveals a lively town oriented around the railroad, lumber industry, and tourist travel. The Conoco tanks are alongside the tracks (left) as is the depot, built in 1926 (distance, center). AHS, PC180, Folder 66, #C.

2018 Flagstaff remains vibrant, with a current population of over seventy-five thousand. I enjoyed strong morning brew at Wicked Coffee and peeked in the windows at Flagstaff Pawn, two businesses on the site of the Conoco Station just beyond the former railroad spur (right). Much of the rest of the north-side block still supported small businesses. On the highway's south side, a mix of parking lots and warehouses paralleled the tracks, and I could still pick out the depot (now also a visitor center). Author photograph.

1940 Wallace's view of the improved highway was along US 66 west of Flagstaff. He notes in his log books that he is documenting the "new concrete pavement construction between Bellemont and Williams various places." West of Parks he captured the concrete, the San Francisco Peaks (distance, left), and the pine forests of the Coconino Plateau. AHS, PC180, Folder 65, #79–1.

2016 Concrete portions of the highway between Flagstaff and Williams have been selectively preserved and—for old-road enthusiasts—they are much coveted segments of old US 66. I followed signs that verified the route's historic gravitas, easily finding the hilltop spot where Wallace stopped more than seventy-five years earlier. My view of the San Francisco Peaks was partially obscured by pine trees that had multiplied across the scene. Author photograph.

1946 Norman photographed this view of US 66 near Williams to document the improved road surface speeding drivers across Arizona's mountain backbone. Wallace was now the chief location engineer for the Highway Department, and he used his work on US 66 to demonstrate how modern roads were remaking the state in the postwar era. With typical brevity, Wallace noted this view was "good" in his log books. It looks east on a day that portends afternoon showers. AHS, PC180, Folder 65, #E.

2016 Flash ahead seventy years. No doubt this was the busiest stretch of US 66 I encountered with Norman: big-rig trucks—horns blaring—whizzed by my spot adjacent to the yellow line. When four-lane Interstate 40 was created here in the early 1960s, engineers used the old alignment to create eastbound lanes for the new freeway and then added a pair of westbound lanes (left). Among encroaching pine trees, I could still spot an older segment of the highway on the distant hill (center right). Author photograph.

1948 After World War II, Ash Fork hummed with cross-country traffic. An elegant Harvey House (the Escalante) stood at the town's west end along the Santa Fe rail line (distance, center). This view, on the right, includes three gas stations—Texaco, Union, and Standard—and assorted bars, cafés, and stores serving travelers along US 66. Home to seven hundred people, Ash Fork exported its local flagstone to postwar patios all across the Southwest. AHS, PC180, Folder 217, #0012.

2016 Three daggers in the heart: First, the railroad moved its main line ten miles north of town in the 1950s. Second, a fire in 1977 torched much of downtown (left). Finally, it was death by interstate in 1979 when the town was bypassed. There's still a smattering of US 66 nostalgia and hope by locals for rekindled prospects. Meanwhile, second-growth vegetation reclaims downtown (left), and the Arizona Café has been converted into the Trinity Methodist Church (distance, right). Author photograph.

1933 Wallace inspected this newly oiled road on a trip between Prescott and Kingman. After 1883 Peach Springs (distance, right) enjoyed prominence along the Santa Fe (far right) and was home to a Harvey House restaurant. Its second life came with traffic along US 66 in the 1920s and 1930s. It offered cabin camps, gas stations, and restaurants to weary travelers. It also served as a headquarters for the Hualapai Indian Reservation, created in 1883. AHS, PC180, Folder 247, #0031.

2016 This isolated stretch of old US 66 is a favorite for nostalgia seekers. Wallace's photograph—taken west of town— captured the same juniper-studded hills and rail line I encountered. Traffic was light. Peach Springs bustled with a mix of visitors and local Hualapai residents (the town remains a tribal administrative center). One midtown gas station was abandoned, but the internet café across the street attracted plenty of business. Author photograph.

1933 The sharp curves and steep grades over Sitgreaves Pass were the last major challenge that drivers faced as they neared California. Travel on the pass across the Black Mountains traced its roots to Beale's Camel Expedition in 1857. Wallace knew this "crooked mountainous road" well and pointed to hazards such as the route's narrow width and its lack of guardrails. Thimble Butte (left) and the Hualapai Mountains (distance, center) are also visible in Wallace's fine panorama. AHS, PC180, Folder 64, #Z.

2016 Still narrow. Still no guardrail. But when I arrived at Norman's spot, old US 66 was wearing a new coat of asphalt and a bright pair of yellow center lines. I enjoyed how Wallace's image addressed practical issues of highway safety at the same time that its aesthetic composition so beautifully captured the time and place. Author photograph.

URBAN ARIZONA

Sentinel Peak stands west of downtown Tucson. It became one of Wallace's favorite haunts above the city. As an image maker—someone sensitive to how stories are told in visual ways—Wallace accumulated an amazing sequence of multiple-plate panoramas of the city's growing skyline and sprawl. One of his favorite views—and a fine perspective for me to revisit ninety years later—came from a point above Congress Street. His view looked east toward town. Just like me, Wallace enjoyed retaking these scenes and seeing the city grow beneath him.

More broadly, Wallace knew Arizona's cities well: he spent his early years living in Tucson, got married in Prescott, and shared retirement with his wife Henrietta at a comfortable home in Phoenix. His images of urban Arizona were created both for work and pleasure. At times Norman's talents were called upon to document the completion of viaduct and bridge projects or street paving and redesign initiatives. During the Depression and New Deal eras, federal grants from the Works Projects Administration (WPA) flowed into the state, funding important improvement projects in cities such as Tucson and Phoenix. Wallace's images documented these changes for the Highway Department, envisioning them as improvements that were making cities better, cleaner, and more efficient.

Urban landscapes also attracted Norman in more aesthetic, visceral ways. In addition to his larger urban panoramas, he made images of interesting urban localities (depots, churches, commercial blocks). He also enjoyed photographing

opposite Prescott's Gurley Street (circa 1940). AHS, PC180, Box 40.

parades and special events (imagine images of politicians in convertibles and mounted cowgirls waving to the crowd).

Arizona cities followed predictable paths of expansion. While initial urban settlement in Tucson, Prescott, and Phoenix was often haphazard—a scattering of stores, churches, and houses—later development followed the logic of land surveys, usually a gridded plat that ordered development along rectilinear streets and blocks. This was the urban world that Wallace entered in the early twentieth century as Tucson's numbered streets and avenues grew mostly north and east of the city center, as Prescott's Gurley Street (east–west) and Montezuma Street (north–south) anchored the stately Yavapai County Courthouse, and as Phoenix grew to fill the Valley of the Sun with new shops and homes. As Norman witnessed Arizona's later growth—especially in the post–World War II era—the urban landscape he helped transform continued its outward trajectory, mostly replicating the predictable grid until mountains intervened or until the curving streets of newer, planned subdivisions interrupted the pattern.

What did I find on the streets of Phoenix, Prescott, and Tucson? What lessons did Norman help me understand? Consider three stories to help answer this question as I thought about the differences between Norman's urban experiences and mine. Most obviously, there were signs of *transformative spatial growth* everywhere I went. These cities got bigger, much bigger, often in record time. So many new urban and suburban landscapes in Arizona have sprouted from open, thinly settled tracts of arid land.

I saw how the rugged desert foothills near Tucson's Sabino Canyon are now an assortment of mini malls and fashionable homes and how the city's entire north side has been remade into a sprawling community of low-rise housing punctuated by occasional office buildings and edge-city congestion.

In Mesa—now an older inner suburb of endless Phoenix—the restorative Buckhorn Baths once stood alone, bordered only by sand and scorpions. Today the old buildings are surrounded by a suburban neighborhood of trailer parks, a Walgreens, and the local Jack-in-the-Box. Though the scorpions are probably still around, the baths are closed, no doubt to be swept aside by Mesa's continued growth.

Revisiting central cities also revealed *an increasingly vertical urban landscape*. Downtowns still matter, and they have been home to a great deal of development since Wallace's time. Even though we often think of western cities as dispersed, less a land of skyscrapers than of endless suburbs, the opposite is increasingly true: today Phoenix, Las Vegas, and Los Angeles are surprisingly among the nation's most densely populated cities. In addition to the commercial banks and civic centers we associate with downtown, more and more people are choosing to live in these settings.

Looking south on Central Avenue toward downtown Phoenix, I realized how the open, sky-filled landscape of Norman's time had been replaced by a more all-enveloping array of glass and steel. I marveled how the once visually dominant Security Building, built in 1928, was still there, though now it is overwhelmed by the corporatized vertical world that towers above.

Tucson has changed in similar ways. I enjoyed hanging out for multiple mornings by the Stone Avenue underpass north of downtown. The underpass allows traffic to avoid the busy railroad tracks. It was completed and then photographed by Wallace in the mid-1930s. Remarkably, the attractive, well-designed underpass looks almost identical today, but Tucson's increasingly vertical downtown skyline is hard to miss.

A third urban theme emerged as I wandered

Norman's city beat. In some settings there was more visual continuity in the landscape, but *stylistic and functional changes* marked these localities. How does a landscape change yet remain the same? Tucson's railroad depot offered one example. On the one hand, the trackside site has remained at the same spot just north of downtown for more than a century. But the building's style evolved with the times, passing from an early Victorian iteration to different Spanish Colonial Revival motifs. Furthermore, the building's function has morphed over the decades, and today it supports—in addition to the Amtrak station—various upscale businesses and an event center that cater to downtown Tucson's gentrifying population.

A similar example greeted me along Prescott's Gurley Street. The city's main urban boulevard attracted Wallace's interest repeatedly in the 1920s and 1930s. Around 1940 he took a photograph—the subject of one of his early color Kodachrome studies—dominated by the Hassayampa Hotel and by the Elks Building (complete with theater and a rooftop elk statue). When I arrived at the spot, I delighted in the elk's longevity and in the Hassayampa's survival. Indeed, the street's urban character seemed as enduring as Thumb Butte west of town. But a closer look revealed more complexity: the Elks building has been completely renovated; the corner Bank Building is a boutique; the Hassayampa has had a total interior facelift; and the Valley National Bank building is home to a real-estate office and a decorative-candle store. The meaning was clear: urban landscapes change to fit the times. While Wallace would recognize Gurley today, the street now caters to my era, not Norman's.

1937 Wallace stood out front of the Westward Ho Hotel, on Central Avenue in Phoenix, and looked south. His view includes a service station and a parking garage for the hotel (left). The famed Apache Hotel is down the block. To the west, small businesses (a storage company, cleaners, a market, and a café) line the nearest block (right), while the Security Building—built in 1928 by Dwight Heard in the Second Renaissance Revival style—dominates the skyline beyond (right). AHS, PC180, Folder 248, #0227.

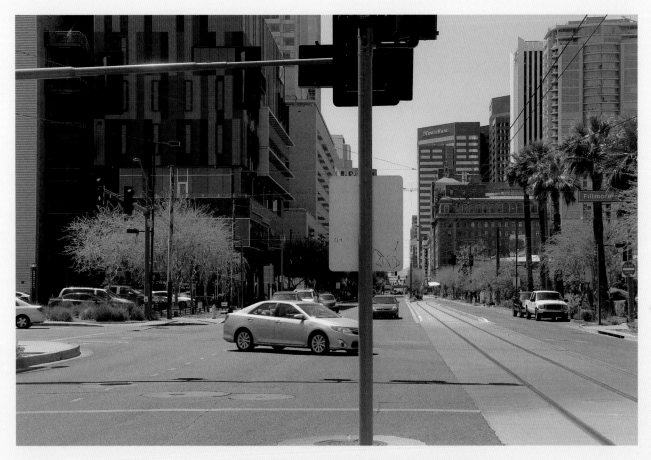

2016 I stood on a small island and found Norman's position, complete with pole and sign. Transportation planners had been busy: note the one-way traffic flow and tracks for the Valley Metro Rail system, completed in 2008. The large, multi-toned building houses a downtown extension campus for Arizona State University (left). Street-side palm trees and the Security Building survive (right) but are now overshadowed by the tony thirty-four-story Monroe Apartments (far right) and the metallic sheen of Renaissance Square (distance, center right). Author photograph.

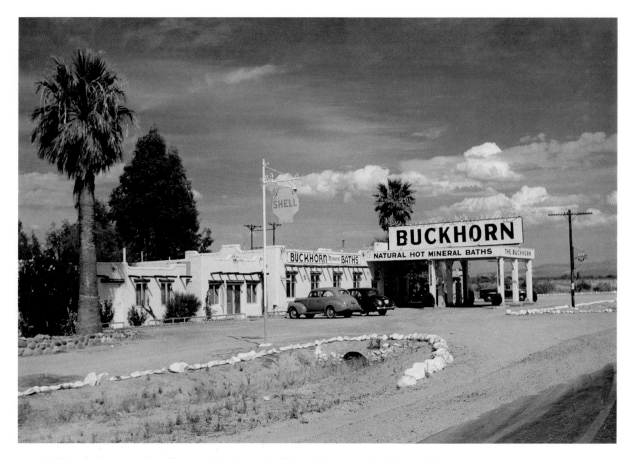

1944 "Hell, they had hot water; lots of hot water right there on the highway," Norman laughed in his oral history
recording as he recalled the discovery and development of Mesa's Buckhorn Mineral Baths in 1939. While Mesa already
had seven thousand residents, the Baths (and Shell Station) were still surrounded by open land. Reflecting Arizona's
tradition as a health resort, the attraction ("Mineral baths that make you live again") also boasted a cactus garden, a fish
pond, and a wildlife museum. AHS, PC180, Folder 273, #0255–7.

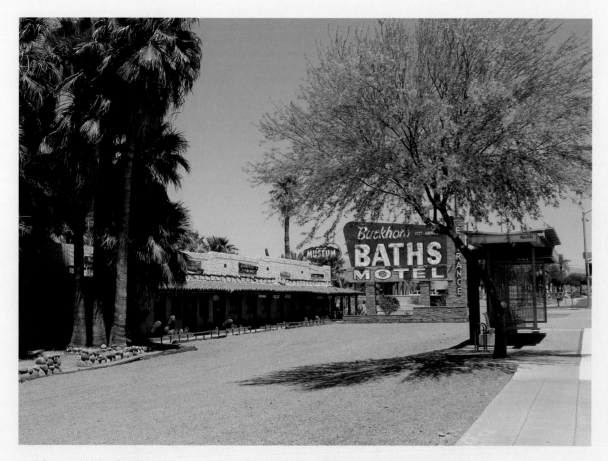

2016 "Are you thinking of buying it?" The question came from a pedestrian strolling toward the bus stop. The empty Buckhorn Baths Motel (a later version of the development) was for sale. Surrounded by shopping centers, fast-food outlets, and mobile-home parks, the old buildings—abandoned for several years—await the suburban wrecking ball. Hopefully developers save the mature palm trees and put the hot water from the springs to good use. Author photograph.

circa 1940 In 1907 Prescott's boosters insisted, "She has everything that nature could give her in the making of an ideal place for homes and commerce . . . and the founders of the city were wise and generous in laying out broad streets, at right angles with the cardinal points." No street was broader or more important than Gurley. Wallace's view includes the BPOE (Elks) Building (left), Thumb Butte (distance, center), and the imposing Hassayampa Hotel (right). AHS, PC180, Box 40.

2016 Parked cars still line Gurley Street. To the displeasure of local law enforcement, I dashed repeatedly into Gurley's center lanes to capture Norman's mid-street view. Worth every honking horn, I spotted the renovated Elks Building and the adjacent block of upscale retail shops (left) as well as the gentrified Hassayampa Inn (right). The Valley National Bank has become Armadilla Wax Works and Candle Factory. Today Prescott thrives in the amenity-rich, retiree-filled West. Author photograph.

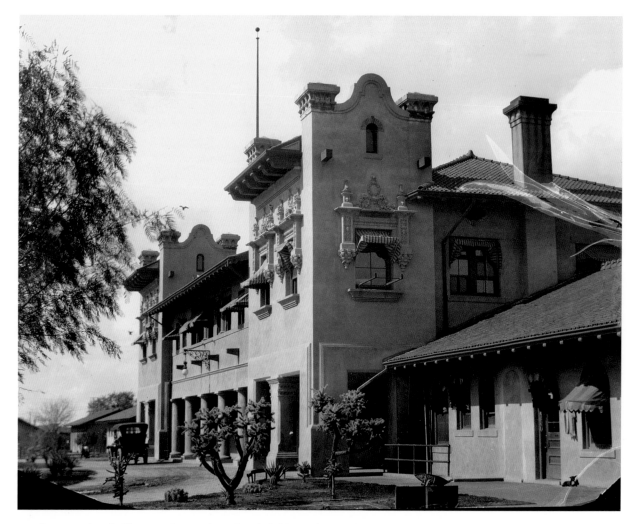

1912 Tucson owed much of its economic expansion to the arrival of the Southern Pacific Railroad in the 1880s. In 1907 Daniel Patterson, architect for the Southern Pacific, designed a fittingly grand and gaudy depot for Arizona's first and finest city. It sat just north of downtown, one block from busy Congress Street. The depot was a baroque, Spanish churrigueresque–style structure when Wallace photographed it in 1912. AHS, PC180, Folder 262, #0109.

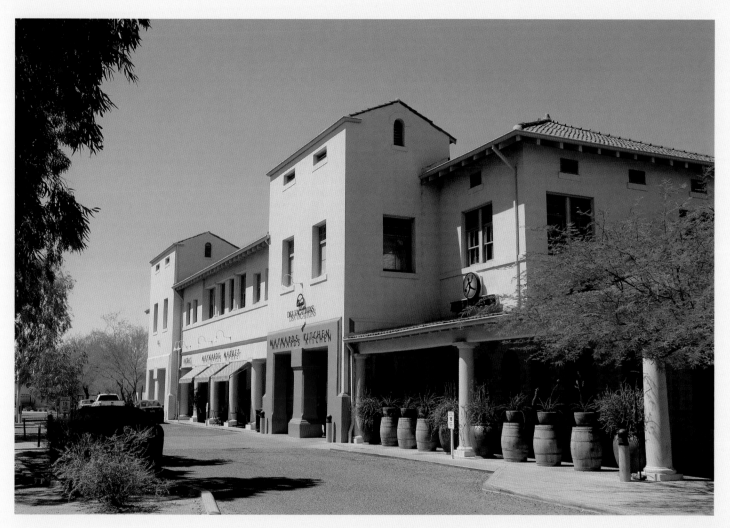

2017 The depot survives, but it has mellowed with time. A makeover in the early 1940s softened the depot's design with a gentler dose of Mediterranean influences, sans rococo curlicues. The City of Tucson purchased the depot in 1998, and the renovated retail center, restaurant, and office complex opened in 2004. I watched as well-dressed couples strolled into gentrified Maynards Market and Kitchen for a meal (right). The Amtrak station is still housed at the building's west end (left). Author photograph.

1927 Norman loved climbing Sentinel Peak west of Tucson. Beginning in 1910, his panoramas captured the changing cityscape. One June afternoon in 1927, Wallace made a multiple-plate panorama of the city, including this view down Congress Street. The tree-lined Santa Cruz River bisects the scene from right to left with downtown beyond. The University of Arizona campus (then with 2,100 students) is also visible (distance, center left). The Santa Catalina Mountains are north of town (left). AHS, PC180, Folder 266, #0507–4.

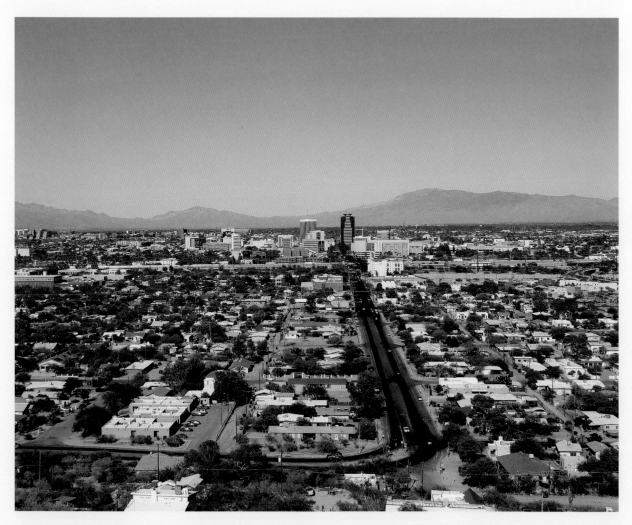

2016 You can find a surprising number of surviving structures—mostly houses—on Tucson's poorer west side. The Santa Cruz River—mostly lined with concrete—is harder to identify, but you can detect the parallel alignment of Interstate 10 nearby. Downtown has flowered, and the University of Arizona campus (now with 45,000 students) is now larger than the *entire city* was in 1927. Even in xeriscaped Tucson, note the enduring tree cover along many city blocks. Author photograph.

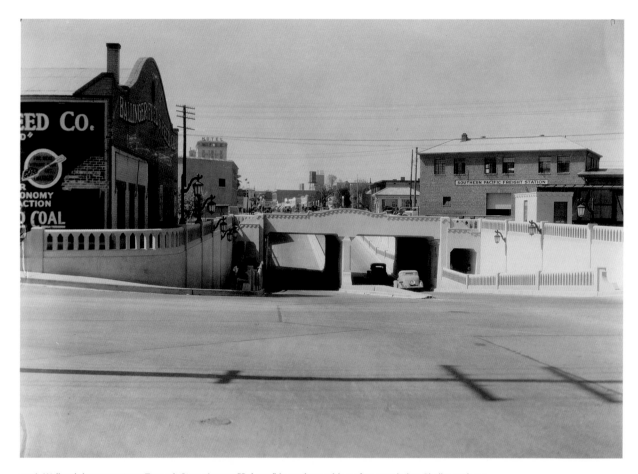

1936 Wallace's image captures Tucson's Stone Avenue "Subway" (or underpass) just after completion. Similar projects remade hundreds of American cities as dangerous, inefficient railroad-track alignments (often through the central city) were bypassed by tunnels and overpasses. Ballinger Fuel and Feed (left) and the Southern Pacific Freight Station (right) are trackside. The Pioneer Hotel (distance, left) dominates downtown. Both pedestrians and cars enjoyed their new freedom. AHS, PC180, Folder 102, #1234.

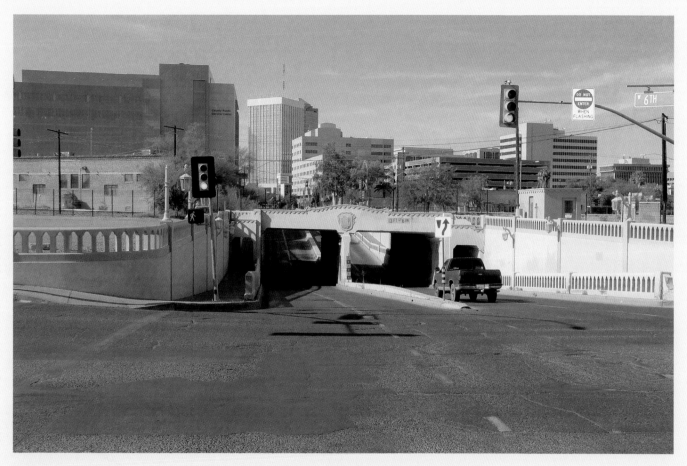

2017 I marveled at the architectural integrity of the underpass and what had changed around it. Trackside real estate had become less essential amid multiplying vacant lots, but downtown thrust skyward. The Pima County Public Service Center (left), the sixteen-story Bank of America Plaza Building (distance, center), and other office and parking structures (distance, right) redefined Tucson's skyline. Summer cloudbursts can still flood the underpass, and residents have christened the giant puddle Lake Elmira, named for the first local girl to swim across it. Author photograph.

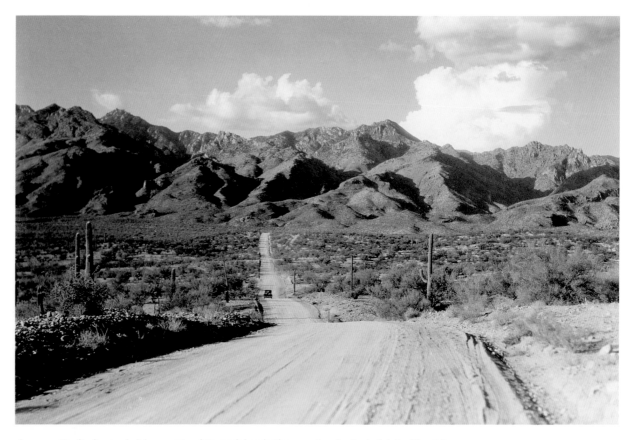

circa 1923 Few landscapes in Arizona captured Norman's imagination more than the Santa Catalina Mountains near Tucson. Part of the Coronado National Forest, the Santa Catalinas possess a diverse ecology that includes both saguaros and pines. This view—far beyond Tucson's urban periphery in the 1920s—captures a single vehicle, perhaps returning from an all-day adventure to Sabino Canyon (distance, right). The aptly named Rattlesnake Peak looms above (center right), and Esperero Canyon is to the west (left). AHS, PC180, Folder 282, #0745.

2016 Breathtaking scenery in the West does not escape notice, especially at the back door of a major metropolitan area. My drive to Wallace's vantage point took me to Tucson's upscale suburbs near Sabino Canyon National Recreation Area. Much of the housing here has appeared after 1980, along with the Walgreens, traffic signals, and strip malls offering takeout sushi and pizza. The dusty bajada along the mountain front is now home to exotic greenery and swimming pools. Author photograph.

FAR CORNERS

The only way to get to Arizona's Wolf Hole is from St. George, Utah. It was a beautiful May afternoon, and I left behind the bustle of Utah's Dixie, letting the dirt road guide me south, into the Arizona Strip, a vast, thinly peopled region northwest of the Grand Canyon. This is ranching country, as much linked to Nevada and Utah as it is Arizona. Here, cows far outnumber people. Culturally it shares roots with Utah, as small colonies of Latter Day Saints spilled south into the Strip from their Mormon heartland. Former local resident and western writer extraordinaire Edward Abbey boasted that his books "always made the best-seller list in Wolf Hole."

opposite Heading for Utah (1950). AHS, PC180, Folder 311, #0402–5.

Norman's image of Wolf Hole, taken sixty-eight years earlier, drew me there. It showed a dusty road, juniper-covered hills, and a small structure and corral. For twenty miles I saw no one, until I finally arrived at a stretch of highway that looked familiar. Though the small building and corral had bit the dust, a nearby fence had survived, and I spotted an identical scar on hills to the north. I parked the car and paced the highway, trying to get the distance from the old homestead right. As I took photographs I noticed a pickup truck in the distance, and soon several more appeared.

It had to be the busiest day in Wolf Hole that spring. When the first pickup pulled up, I noticed the casket in the bed, wrapped with a quilt and marked with flowers. The driver rolled down his window, and we chatted. He was curious about me, wondering if I had car trouble. I showed him my old photograph, he smiled, and we began talking about his childhood memories of the nearby ranch. He told me he was a local boy, born and raised there, taking his Aunt Aileen to be buried on Mount Trumbull, far to the south near the Grand Canyon. Over the next hour I saw a parade of family continue the trek south. Almost every vehicle stopped, and I had quite a time explaining my presence. One more vehicle passed, more chatting, and then a face I recognized. I realized I had just met much of the Bundy family.

The Bundys—longtime ranchers in the Strip and in southern Nevada—became nationally known through their protests over federal lands policies. Refusing to pay grazing fees on public lands, the Bundys had drawn the ire of federal officials and the spirited support of anti-government elements across the rural West. After a nationally televised armed standoff with federal officials in 2014, several Bundy family members—including Cliven and his son, Ammon—were charged with an assortment of federal crimes. A botched trial by federal prosecutors freed the Bundys a few months before my meeting with the family in the Wolf Hole.

Thanks to Norman—in addition to meeting the Bundys—I had other opportunities to discover Arizona's far corners. Many of these localities were in odd, out-of-the-way spots in the state, and I learned in such places how landscapes could produce unexpected encounters. For example, there was the photograph of the highway junction just north of Bisbee. I had chosen the view, taken in 1942, because of its bare simplicity: one desert road becoming two beneath distant rocky cliffs. Things got more interesting when I arrived, and I found that the highways had been completely realigned, and the original road had disappeared. Surviving fence posts were the only thing that saved me as I wandered through the grass and mesquite that had invaded after the road was abandoned.

Norman's love of far corners also took him to Arizona's southern and northern borders. He liked border images for the same reasons we do: our eyes are drawn to the border itself, to the changes we see from one side to the other and to what that tells us about the power of borders to shape land and life. Norman also knew that borders were both barriers and meeting places, making them interesting localities to photograph. I enjoyed traveling with Norman to Nogales, on the border with Mexico, and then to the Utah line, on Arizona's northern edge. No doubt Norman was already aware of the stark contrast between these two borders, even many decades ago, where he witnessed differences that have only grown in today's world. At Nogales, however, even with the hardened signatures of the international boundary, I appreciated the casual flow of pedestrians crossing north into the United States—many on their daily shopping and work routines—through the checkpoint that appeared both in Nor-

man's view and in mine. It reminded me how Nogales—in two parts—is really a single city, unified by proximity, family ties, and mutual interests. Norman's own life included an easy fluency with both English and Spanish, many surveying jobs in Mexico, and frequent crossings at that same location along the border.

On the state's northern edge, always on the hunt for a photo-op, Norman parked his state car just a few feet from the Utah line, hiked up a nearby hill, then aimed his camera along the stark barbed-wire fence that divided the Beehive State from the Grand Canyon State. The scene—bare hills almost devoid of life—had an otherworldly quality to it. My view about seventy years later was easy to find once I discovered the now-abandoned highway that dead-ends at the Utah line. Like Norman I obligingly parked my vehicle and walked up the hill. The place had changed: a newly built freeway linked the area to St. George, and I listened to traffic roar past as I leaned across the fence—from one state to the other—to capture the view. All around me a blizzard of off-road vehicle tracks—on both sides of the fence—had filled the scene with ruts and tread marks.

Arizona's far corners treated me well, inviting me to look at landscapes that I normally ignore, taking me to localities that each had their own stories, narratives of people and place, and revealing landscapes that had sometimes changed, sometimes not. Norman was my reason for traveling to these spots—a fine excuse to amble, look carefully, revisit his moment there, and then peer through the camera lens to discover mine.

1939 Wallace knew Nogales well, traveling through the border town on trips south to work in Mexico. This view at the end of Morley Avenue—a major commercial block—looks east along International Street. A chain link fence bisected "Ambos Nogales" (both Nogales) and funneled border movements—both wheeled and pedestrian—into well-marked crossing stations. Handling foot traffic only, the tile-roofed Morley Gate Border Station (center left) was erected on the US side in the 1920s. AHS, PC180, Folder 246, #0211.

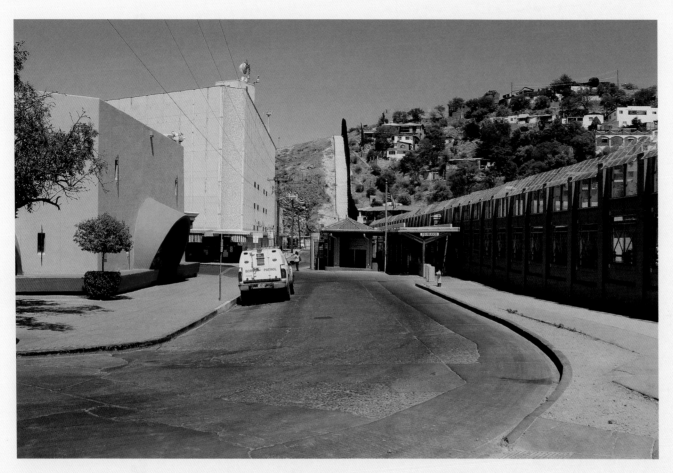

2016 Although Wallace called Nogales the "most quiet and peaceful of any of the border towns" in the 1930s, business has picked up. The hill above town remains clear of structures on the American side (for security), but houses crowd slopes south of the border. The Morley Gate remains, renovated in 2011. On busy days, more than ten thousand pedestrians cross through, many on local business and shopping errands. The old chain link fence has been considerably hardened. Author photograph.

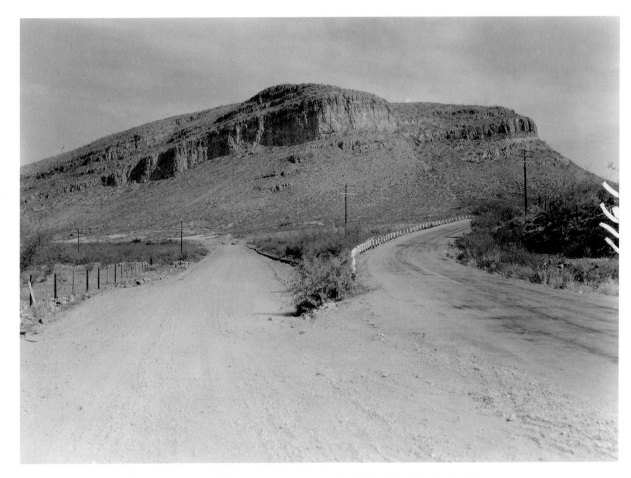

1942 Wallace lived in four different places during 1942, including Feltons Corner (northeast of Phoenix), Casa Grande, Bisbee, and Flagstaff. Each temporary home focused on nearby highway jobs, and Norman spent March through July working near Bisbee. This view—highlighting safety issues at the junction—looks north at the division point of US 80 (right) and State Route 90 (left), about eight miles north of town. AHS, PC180, Folder 86, #1161.

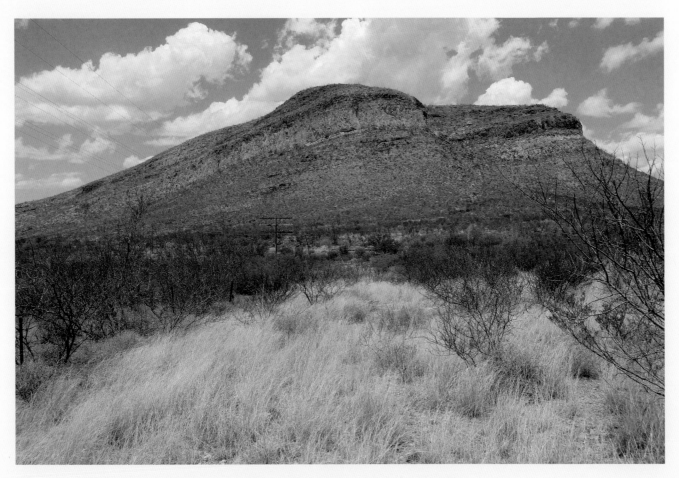

2016 Jeans and boots are valuable field wear, even in an Arizona summer. The highway junction was completely redesigned a short distance to the east (off camera, right). As traffic roared nearby, I looked for the old alignment to reproduce Norman's view. After seventy years of abandonment, encroaching mesquite and buffel grass had obscured the old gravel roadbed, but the fence line (left) and the general orientation of nearby hills gave me hope I was close to Wallace's original spot. Author photograph.

RAIN VALLEY RANCH

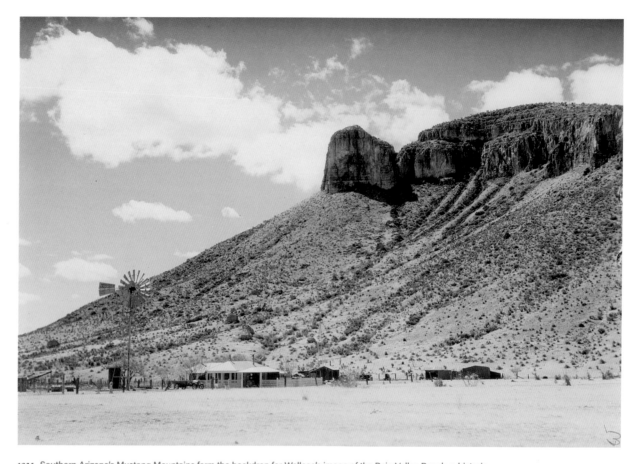

1935 Southern Arizona's Mustang Mountains form the backdrop for Wallace's image of the Rain Valley Ranch, a historic
cattle operation southeast of Tucson. Wallace lived in the region for several months in 1935, improving roads between
Elgin and Sonoita. This view shows the ranch house, outbuildings, windmill, and corrals (left). The valley flats (foreground)
have been recently grazed. AHS, PC180, Folder 315, #1329.

2016 I moved slightly from Norman's spot because widespread mesquite invasion blocked my view of the flats and ranch house. The house is still on the property, and I found the foundation of the windmill. The Arizona Land and Water Trust has partnered with the Department of Defense (Fort Huachuca is nearby) to purchase conservation easements from the ranch, keeping it free of development and protecting rare species such as the North American jaguar and the Chiricahua leopard frog. Author photograph.

1934 Wallace's image looks west from Coyote Pass, a small divide along US 93 just northwest of Kingman. This view shows an early alignment of AZ 68 as it crosses the Golden Valley heading for Union Pass and the Colorado River beyond. At the time, Wallace lived in Kingman, working on multiple highway projects in western Arizona. This picture was taken on a Sunday trip as Norman explored old mines and the future site of the Davis Dam. AHS, PC180, Folder 72, #2420.

2016 The setting in Norman's time looked so remote, the classic dirt-road-across-the-desert scene. Real-estate development has domesticated Golden Valley into an unincorporated suburb of Kingman and Bullhead City. Much of the valley (population over 7,500) is subdivided into 2.5-acre lots, peppered with modular houses and mobile homes. Such informal sprawl is ubiquitous across Arizona, where residents enjoy affordable open space but are still only a short drive to Walmart. Behind me, traffic roared by on US 93, a route Wallace helped build. Author photograph.

circa 1938 Tuba City became part of an enlarged Navajo Reservation more than a century ago. The Tuba City Trading
Post was an enduring local institution and a key conduit of trade and interaction between Navajo and Euro-American
worlds. The octagon-shaped blue-gray sandstone structure photographed by Wallace—complete with gas pump—was
constructed around 1920. Zane Grey frequented the spot in his Arizona wanderings, and Teddy Roosevelt also paid a visit.
AHS, PC180, Folder 261, #0021–5.

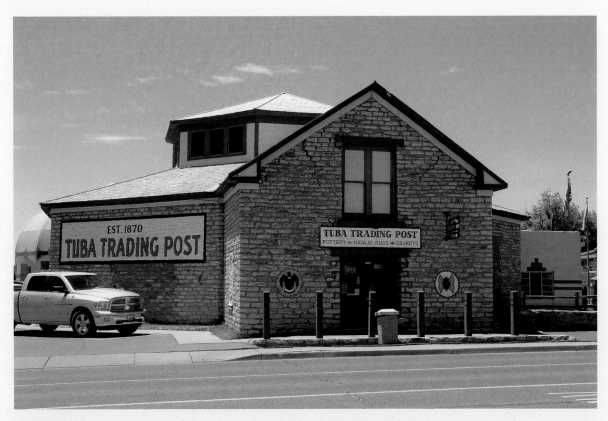

2016 The structure has seen major interior renovations since the late 1930s, and today the Trading Post is largely devoted to displaying and selling Native arts and crafts. It was purchased by Navajo Nation Hospitalities, Inc., in 1999. Although the gas pump left the scene and additional Native-owned buildings are visible nearby, the structure—with a few added cracks—looks similar. Norman would have been curious about the McDonalds and Taco Bell across the street. Author photograph.

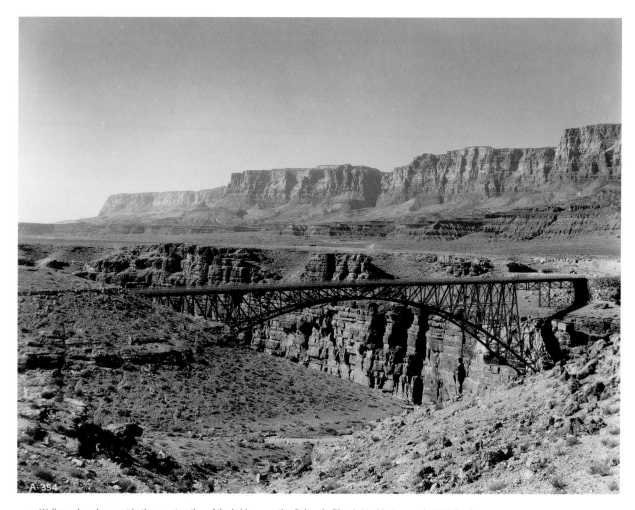

1933 Wallace played no part in the construction of the bridge over the Colorado River's Marble Canyon in 1929, but he admired its engineering elegance. The steel structure soared more than 460 feet above the river and provided a critical crossing that eliminated the need for Lees Ferry nearby. He scrambled across rocky slopes east of the bridge to capture this view. AHS, PC180, Folder 165, #1236.

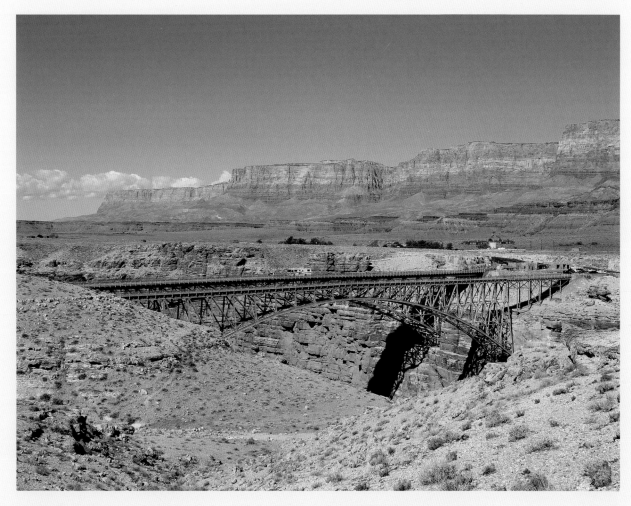

2018 I eventually found Norman's hillside spot. It was a gorgeous morning, and the Vermillion Cliffs lived up to their name. Look carefully and you see two bridges, not one. The heavier-duty version was added in 1995 (an RV is midway across it), and the original bridge (foreground) is now reserved for pedestrians and sightseers. Author photograph.

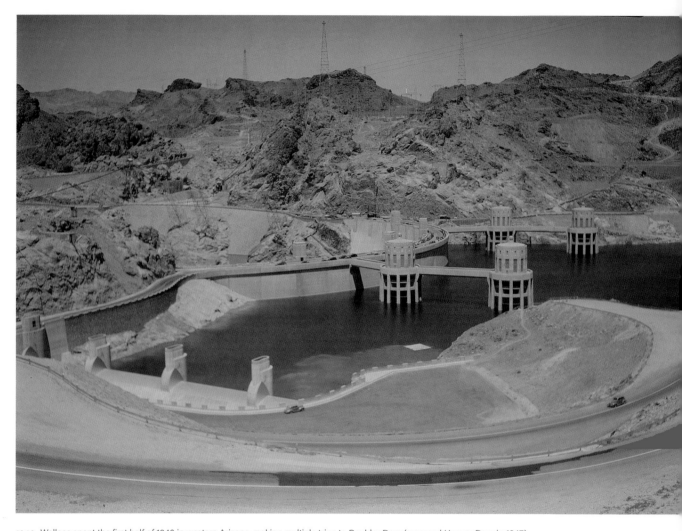

1940 Wallace spent the first half of 1940 in western Arizona, making multiple trips to Boulder Dam (renamed Hoover Dam in 1947). Straddling the Colorado River's Black Canyon and the boundary between Arizona (foreground) and Nevada (background), the 3.2-million-cubic-yard concrete arch-gravity dam was a wonder of modern engineering. Wallace repeatedly photographed it, and this color view from 1940 shows Lake Mead and the highway (US 93) across the dam connecting Nevada and Arizona. AHS, PC180, Box 41.

2016 Glancing at the date of the 1940 photograph, I noticed Norman's image was made seventy-six years—to the day—before mine. With the realignment of US 93 in 2010—traffic now crosses the Bypass Bridge to the south (off camera, left)—the main road no longer leads past Wallace's viewpoint. I marveled at the multi-level parking structure (distance, center left) as well as the interpretive center for visitors (center). The growing number of thirsty westerners in a drought-prone land tells the rest of the story. Author photograph.

1950 Highway work took Wallace to the Arizona Strip several times in 1950. This image captures the backcountry character of the sparsely populated Strip, which included all of the isolated land between the Grand Canyon and the Utah border. The scene at Wolf Hole—including corral and cabin—was part of a local cattle-ranching operation. AHS, PC180, Folder 271, #0408–7.

2018 The vehicle in the distance was part of a Bundy family burial procession on its bumpy pilgrimage from St. George to Mt. Trumbull (near the Grand Canyon). The Bundys—longtime ranchers in the area—knew the cattle operators in Wolf Hole and recalled when the cabin still stood. My view captured surviving fence posts (left), the still-dusty road, and a surrounding landscape steadily being forested by invading junipers. Author photograph.

1950 Between Nevada and Utah, US 91 ran through the Virgin Valley and a tiny sliver of the Arizona Strip. The road was on Norman's beat, and in 1950 he spent time improving it. This view—taken near the highway (off camera, left)—looks northeast toward the Virgin Mountains. Farmers scattered along the valley bottom irrigated their pastures and small fruit orchards, their fortunes linked to those of the Virgin. AHS, PC180, Folder 240, #0076.

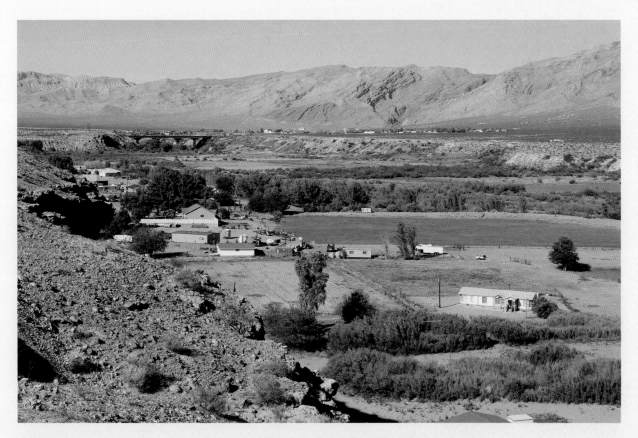

2018 The valley retains a rural flavor, and the Virgin Mountains look predictably desolate, but quiet changes reshape the scene. A multilane bridge (Interstate 15; distance, left) spans the river, and I spotted billboards and highway-related services in Littlefield (distance, right). The fruit orchards and many older homes have vanished, but widespread (and unwanted) invasion of water-loving salt cedar (tamarisk) now crowds the river and adds undesired greenery to the valley floor. Author photograph.

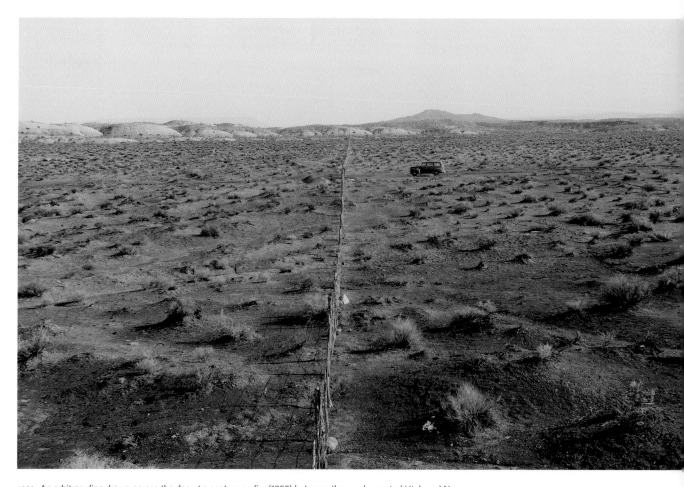

1950 An arbitrary line drawn across the desert a century earlier (1850) between the newly created Utah and New Mexico Territories ordained the linear geometry Wallace captures in this view. Later, when a recognizably shaped Arizona Territory emerged from Civil War dickering (1863), the line was set, although Utah attempted without success to annex the Arizona Strip on multiple occasions. This lonely spot is a few miles south of St. George, Utah. AHS, PC180, Folder 311, #0402–5.

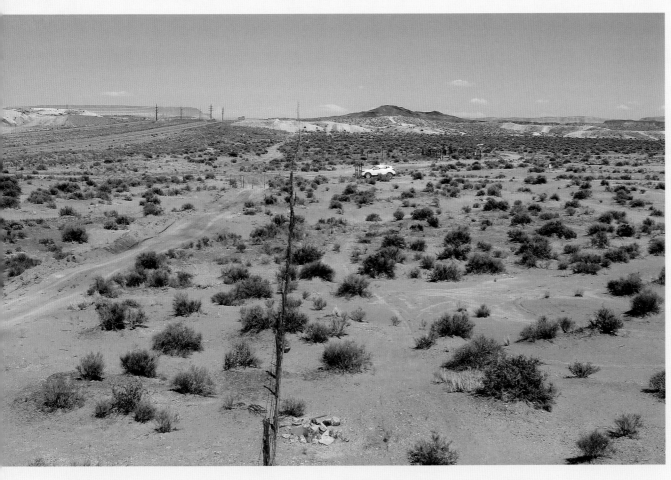

2018 The growing influence of St. George was obvious as I honed in on Wallace's state-line view. A new freeway (left) has reworked nearby hills and will facilitate suburban sprawl into Utah's most southern edge. For now, off-road vehicles are actively preparing the ground for more permanent settlement. I enjoyed the simple technology of the enduring barbed-wire fence, little changed since Norman's time. Author photograph.

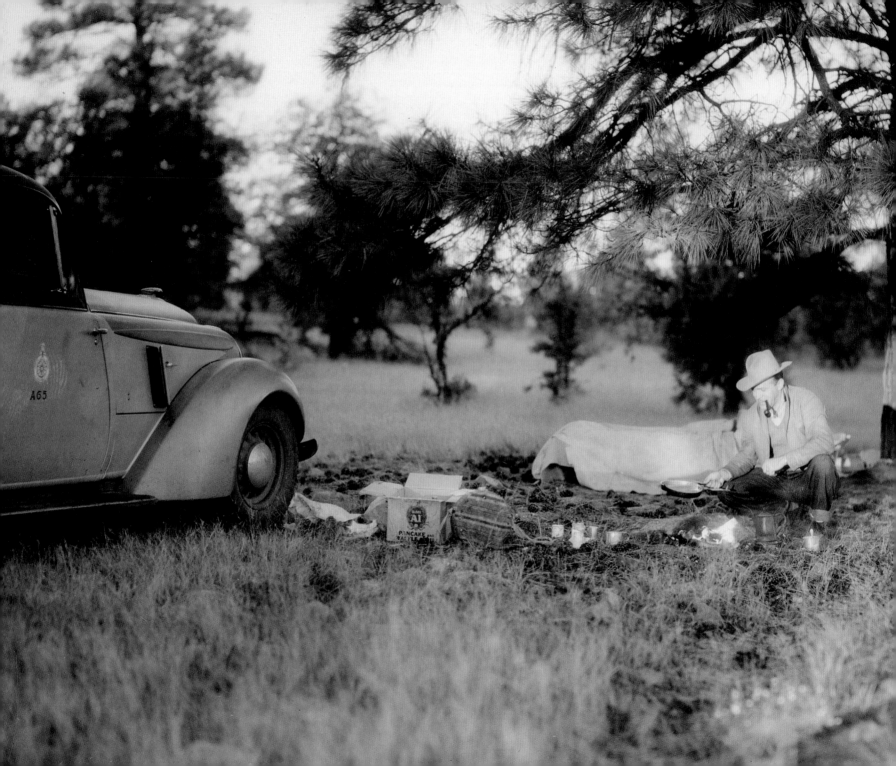

After Norman retired from the Highway Department in 1955 at age seventy, his world gradually contracted. You can follow the story in his log books. For several years he enjoyed making shorter trips around Arizona, photographing highways he had worked on or revisiting old work camps and memorable tunnels, bridges, and overpasses. In his later years he favored Ektachrome color slide film.

He organized, catalogued, and donated thousands of his prints and negatives to the Department of Transportation (now at the Arizona Historical Society) in 1968. By 1970, at age eighty-four, his world and his images had become increasingly intimate and local: there were pictures of the new Chevrolet, the big cloud above the house, the approaching dust storm, a sunset. You can still feel his engagement and enjoyment of the visual world, but that world was shrinking, a far cry from his backroad adventures in the desert. Norman's final photo entry in his log books—in a shaky hand—

describes his visit at age ninety-one to a neighbor's flower garden. His mobility and health declined further in his final years, and he died in 1983 at the age of ninety-eight in Phoenix.

As an image maker Wallace's engineering eye—his precise and intuitive understanding of clean, visual geometry—served him well. I sometimes wondered if he ever explored modern Precisionism—the art of Charles Demuth or Charles Sheeler—because the spare yet forceful lines in their work seemed effortlessly to run through Norman's own engagement with his subjects. I enjoyed the fact that his visual voyeurism—of clouds, a road, or a small-town Main Street—was subtle and straightforward, leading me to the place without pomp or pedantry. I liked how he inserted himself gently into his art, allowing everyday landscapes—their morphologies, linear and otherwise—to speak simply and directly to me.

That world view of ordinary Arizona places produced an enduring body of creative work,

opposite Norman Wallace at camp with Highway Department vehicle (no date). AHS, PC180, Folder 208, #0144.

especially when it was combined with his own standards for high-quality photography, his intimate knowledge of cameras and film, and the beauty he created making prints pop off the page. Wallace loved a crisp story well told, and his technical acumen made that possible.

Then there was his own life story, the rich, long threads of experience, jobs, and travels that took him to so many remarkable places in Arizona at a time when most corners of the state were still beyond the pale of casual adventuring. Norman possessed the energy and had the opportunity to combine hard work—many of his surveying days were epic, brutal, and surreally hot—with an unquestioned and unquenchable aesthetic for what he found fascinating and unique in his adopted home state.

What we gained with Norman's images—the sheer abundance and diversity of Arizona landscapes that he photographed—is an unmatched record of twentieth-century change in a part of the American West that had suddenly been catapulted into the modern world. It was an exhilarating, jarring, disruptive, and formative time for Arizona. Norman helped make it all happen by surveying railroads and locating highways, and he also recorded the story as it unfolded, offering us an opportunity to look back to that time through his eyes.

For my part in all this, I think Norman would have gotten a kick out of being followed around. I know my own delving into his photographs and into his log books was a terribly invasive, fascinating, and revealing experience. I think Norman in no small way was defined by what he loved to photograph. His thousands of images are his unwitting autobiography, a window into what fired his hunger for landscapes, the urge to create pictures of a cactus blossom, a road, or an Arizona town.

By doing so he also captured a sweeping photographic tableau of Arizona. This larger story—seen through Wallace's eyes—offers a beautiful, poignant, and disquieting portrait. Looking at how Arizona has been transformed also reminds us of how its changing landscapes reveal our collective autobiography of who we are and what we value as a society. It is the story of uneven, unpredictable change in settings as fragile as they are spectacular.

Finally, Norman's story illustrates how our individual lives are indelibly shaped by where we live. Norman taught me how it pays to look carefully, to think about what you see, and in the end to make it a part of who you are. Perhaps that's the larger lesson of what he discovered about Arizona and what I learned, riding shotgun.

For readers interested in digging into more relevant literature on landscape change in the American West, Arizona's historical evolution and geographical complexity, the practice of repeat photography, or Norman Wallace's own life, I can recommend a variety of resources that served me very well throughout this project.

For broader insights on landscape change across the West, see my *How to Read the American West: A Field Guide* (Seattle: University of Washington Press, 2014) and its own extensive bibliography. On the broader value of interpreting everyday vernacular landscapes, see D. W. Meinig, ed., *The Interpretation of Ordinary Landscapes* (New York: Oxford University Press, 1979); Michael P. Conzen, ed., *The Making of the American Landscape* (New York: Routledge, 2010); and J. B. Jackson, *Landscape in Sight: Looking at America* (New Haven: Yale University Press, 1997).

On western American history, two excellent references remain Patricia Limerick, *The Legacy of Conquest: The Unbroken Past of the American West* (New York: W. W. Norton, 1987) and Richard White, *"It's Your Misfortune and None of My Own": A New History of the American West* (Norman: University of Oklahoma Press, 1991). For a brief, readable assessment of the South-west, see D. W. Meinig, *Southwest: Three Peoples in Geographical Change, 1600–1970* (New York: Oxford University Press, 1971). A wonderful and informative blending of regional history and the history of technology is Martha A. Sandweiss, *Print the Legend: Photography and the American West* (New Haven: Yale University Press, 2002). An excellent assessment and sampling of western landscape photographers is Rachel M. Sailor, *Meaningful Places: Landscape Photographers in the Nineteenth-Century American West* (Albuquerque: University of New Mexico Press, 2014). The work of early Arizona photographers can be appreciated in Jeremy Rowe's handsome volume entitled *Photographers in Arizona, 1850–1920: A History and Directory* (Nevada City, CA: Carl Mautz Publishing, 1997).

For Arizona history I recommend Thomas E. Sheridan, *Arizona: A History* (Tucson: University of Arizona Press, 2012). An older but still useful interpretation is Lawrence Clark Powell, *Arizona: A Bicentennial History* (New York: W. W. Norton, 1976). For Arizona's roadside history it is hard to beat Marshall Trimble, *Roadside History of Arizona* (Missoula, MT: Mountain Press, 1986). The *Moon Handbooks* series has published some informative and entertaining guidebooks on the state. See Bill Weir, *Arizona*

(Emeryville, CA: Avalon Travel Publishing, 2005) and Tim Hull, *Arizona and the Grand Canyon* (Berkeley, CA: Avalon Travel Publishing, 2016).

I also profited from other scholarly and interpretive works focused on Arizona and the Southwest during Norman Wallace's life. I especially recommend Richard V. Francaviglia and David E. Narrett, eds., *Essays on the Changing Images of the Southwest* (College Station: Texas A&M University Press, 1994); Marta Weigle and Barbara A. Babcock, eds., *The Great Southwest of the Fred Harvey Company and the Santa Fe Railway* (Phoenix: Heard Museum, 1996); Katherine G. Morrissey, ed., *Picturing Arizona: The Photographic Record of the 1930s* (Tucson: University of Arizona Press, 2005); Dori Griffin, *Mapping Wonderlands: Illustrated Cartography of Arizona, 1912–1962* (Tucson: University of Arizona Press, 2013); and Kim Engel-Pearson, *Writing Arizona, 1912–2012: A Cultural and Environmental Chronicle* (Norman: University of Oklahoma Press, 2017).

Retracing historical travel around Arizona's early highways was made easier by consulting a variety of maps and guides. I especially recommend Arizona Good Roads Association, *Illustrated Road Maps and Tour Book, 1913*, reprint ed. (Phoenix: Arizona Highways Magazine, 1987); Arizona State Highway Commission, *Arizona Road Map, 1933* (Phoenix: Arizona State Highway Commission, 1933); Automobile Club of Southern California, *Map Showing Principal Automobile Roads within the Navajo and Hopi Reservations* (Los Angeles: Automobile Club of Southern California, n.d.); Automobile Club of Southern California, *Sectional Road Maps: All Southern Transcontinental Routes* (Los Angeles: Automobile Club of Southern California, 1936) (and additional strip-map sets in this series); Automobile Club of Southern California, *Road Map of the State of Arizona* (Los Angeles: Automobile Club of Southern California, 1939); and Automobile Club of Southern California, *Indian Country* (Los Angeles: Automobile Club of Southern California, 1961). A related resource is the classic Federal Writers' Project, *Arizona: A State Guide* (New York: Hastings House, 1940). A useful summary of travel conditions around the state in 1930 is "Condition of Roads on Arizona State Highway System," *Arizona Highways* (hereafter *AZ*), January 1930. An excellent historical study is Arizona Department of Transportation, *Good Roads Everywhere: A History of Road Building in Arizona* (Phoenix: URS Cultural Resource Report 2003–28 [AZ], 2004).

In the growing list of books on repeat photography, I recommend taking a second look at my own *On the Road Again: Montana's Changing Landscape* (Seattle: University of Washington Press, 2006). In addition, explore Thomas R. Vale and Geraldine R. Vale, *U.S. 40 Today: Thirty Years of Landscape Change in America* (Madison: University of Wisconsin Press, 1983); R. R. Humphrey, *90 Years and 535 Miles: Vegetation Changes along the Mexican Border* (Albuquerque: University of New Mexico Press, 1987); Thomas T. Veblen and Diane C. Lorenz, *The Colorado Front Range: A Century of Ecological Change* (Salt Lake City: University of Utah Press, 1990); Peter Goin, *Stopping Time: A Rephotographic Survey of Lake Tahoe* (Albuquerque: University of New Mexico Press, 1992); Mary Meagher and Douglas B. Houston, *Yellowstone and the Biology of Time: Photographs Across a Century* (Norman: University of Oklahoma Press, 1998); John Fieldler, Ed Marston, and Eric Paddock, *Colorado, 1870–2000* (Englewood, CO: Westcliffe Publishers, 1999); George Gruell, *Fire in Sierra Nevada Forests* (Missoula: Mountain Press, 2001); Mark Klett, *Third Views, Second*

Sights: A Photographic Survey of the American West (Santa Fe: Museum of New Mexico Press, 2004); Michael Amundson, *Wyoming Revisited: Rephotographing the Scenes of Joseph E. Stimson* (Boulder: University Press of Colorado, 2014); and James E. Sherow, *Railroad Empire Across the Heartland: Rephotographing Alexander Gardner's Westward Journey* (Albuquerque: University of New Mexico Press, 2014). For some great tips in doing and interpreting rephotography, see Robert H. Webb, Diane E. Boyer, and Raymond M. Turner, eds., *Repeat Photography: Methods and Applications in the Natural Sciences* (Washington, DC: Island Press, 2010).

I also travel in the footsteps of others who have explored Arizona through repeat photography. In particular I benefited from Conrad Joseph Bahre, *A Legacy of Change: Historic Human Impact on Vegetation of the Arizona Borderlands* (Tucson: University of Arizona Press, 1991); Robert H. Webb, *Grand Canyon, A Century of Change: Rephotography of the 1889–1890 Stanton Expedition* (Tucson: University of Arizona Press, 1996); Raymond M. Turner, Robert H. Webb, Janice E. Bowers, and James Rodney Hastings, *The Changing Mile Revisited* (Tucson: University of Arizona Press, 2003); Allen A. Dutton, *Arizona Then and Now* (Englewood, CO: Westcliffe Publishers, 2002); and John H. Akers and Paul Scharbach, *Phoenix Then and Now* (London: Pavilion Books, 2017).

The best way to explore the life of Norman Wallace is to delve into the Norman Wallace Manuscript Collection at the Arizona Historical Society (PC180). Consult the terrific Finding Aid to the collection, available online at http://www.arizonahistoricalsociety.org/wp-content/upLoads/library_PC_Wallace-NormanG.pdf. Within the collection, see boxes 58 and 59 for his photo log books and biographical material. Separately, consult oral histories made by Norman (AV0366, 1975) and his wife, Henrietta (AV0619, 1987). Wallace also penned many pieces within *Arizona Highways* and contributed many photographs (including many covers, beginning in 1932). A sampling of his particularly insightful and representative articles would include (all by Wallace) "Arizonac: A Tale of the Country Which Gave Arizona Its Name," *AZ* (December 1933); "Some Hills Along the Highways," *AZ* (June 1934); "Scenic 89 From Mexico to Utah," *AZ* (February and April 1935); "Highway Adventure," *AZ* (March 1936); "Trailing Highway 60," *AZ* (September 1936); "Two Good Jobs Accomplished," *AZ* (January 1938); "From a Roadbuilders Notebook . . . ," *AZ* (November 1940); and "Arizona 66: The Scenic Wonderland Highway," *AZ* (May 1955).

Wallace's aesthetic attachment to austere desert landscapes reflected and promoted changing cultural attitudes toward nature and the Southwest in the early twentieth century. Some representative books to explore would include John C. Van Dyke, *The Desert* (New York: C. Scribner's Sons, 1901); Mary Austin, *Land of Little Rain* (Cambridge: Houghton, Mifflin, 1903); George Wharton James, *The Wonders of the Colorado Desert* (Boston: Little, Brown and Company, 1906); and Zane Grey, *The Heritage of the Desert: A Novel* (New York: Harper Brothers, 1910).

In my more detailed explorations into Wallace's views and my own, I relied upon many additional resources that readers may find helpful. On Arizona's natural fundament, dig into Halka Chronic, *Roadside Geology of Arizona* (Missoula, MT: Mountain Press, 2017) and James Kavanagh, *The Nature of Arizona: An Introduction to Familiar Plants, Animals and Outstanding Natural Attractions* (Tampa, FL: Waterford Press, 2016). Improvements along the Navahopi Highway are described in *AZ* (July 1935). The Flagstaff Watershed Protection Project is described in "Trails close as

Flagstaff watershed protection work starts," *Arizona Daily Sun* (March 26, 2016). Additional information on the Chiricahua Mountains can be found in Carl Sauer, *Basin and Range Forms in the Chiricahua Area*, University of California Publications in Geography 3, No. 6 (Berkeley: University of California Press, 1930) and in Alden Hayes, *A Portal to Paradise* (Tucson: University of Arizona Press, 1999).

For the detailed story on how the National Park Service stabilized the Wukoki ruins in Wupatki National Monument, consult chapter 6 of Lyle J. Balenquah, ed., "Stabilization History of Wukoki Pueblo (NA203, WS2670)" (National Park Service, 2007). For more details on the restoration of San Xavier del Bac, see E. W. Herreras, "A Report of the Restoration and Preservation of San Xavier del Bac Tucson, Arizona" (Washington, DC: American Institute of Architects Committee on Preservation of Historic Buildings, 1985). The story at Tumacácori can be followed in Frank Pinkley, "Southwestern Monuments Special Report No. 10 Repair and Restoration of Tumacácori 1921" (National Park Service, 1936). A good narrative of the famed Beale Camel expedition is Wallace's own summary in "The Trail of the Camels," *AZ* (October 1934). A brief overview of Pipe Springs is offered in David Lavender, *Pipe Spring and the Arizona Strip* (Springdale, UT: Zion Natural History Association, 1984).

Wallace was fascinated by mining landscapes, and he recorded many of them in Arizona. For those wanting to delve deeper into the broader signatures of mining on the land, begin with Richard V. Francaviglia, *Hard Places: Reading the Landscape of America's Historic Mining Districts* (Iowa City: University of Iowa Press, 1991) and Beth and Bill Sagstetter, *The Mining Camps Speak* (Denver, CO: BenchMark Publishing, 1999). For more on the particulars of the Commonwealth Mine in Pearce, see the Commonwealth Mining and Milling Papers, 1895–1917, AHS, MS 0510.

The Tom Reed gold mine near Oatman is described in Roman Malach, *Mohave County Mines* (Kingman, AZ: Mohave County Pioneers Historical Society, 1977). More on the company mining town of Ruby is available in Tallia Cahoon, "Ruby From Its Heyday in the 1930s to Ghost Town" (Las Cruces, NM: New Mexico-Arizona Joint History Convention, 2002). Additional background on Jerome's colorful history can be found in James W. Brewer Jr., *Jerome: A Story of Mines, Men, and Money* (Globe, AZ: Southwest Parks and Monuments Association, 1973). Ajo's rise, fall, and resurrection can be followed with James Gilluly, "The Ajo Mining District Arizona," USGS Professional Paper 209 (Washington, DC, 1946) and Deborah Fallows, "Ajo, Arizona: A Small Town Pushed to the Brink, and Coming Back," *The Atlantic* (March 30, 2015). The history and fire at Globe's legendary Dominion Hotel can be revisited in "Dominion Hotel 'stately lady' of Globe's Past," *Arizona Silver Belt* (Globe) (December 31, 1981). For more on Bisbee, enjoy Carlos A. Schwantes, ed., *Bisbee: Urban Outpost on the Frontier* (Tucson: University of Arizona Press, 1992).

Main Street and its power as a symbolic small-town landscape in America is effectively explored in D. W. Meinig, "Symbolic Landscapes: Some Idealizations of American Communities," in D. W. Meinig, ed., *The Interpretation of Ordinary Landscapes* (New York: Oxford University Press, 1979), 164–92. On specific tales and descriptions of Arizona's small towns, see Will C. Barnes, *Arizona Place Names* (Tucson: University of Arizona Press, 1988). For more on Cameron, see "Cameron tries to regain Southwest spirit," *The Arizona Republic* (February 1, 1986). Added details on Tortilla Flat are available in Robert M. Brock, *History of Tortilla Flat* (Apache Junction, AZ: Orion Publishing Co., 1985) and in L. L. Lombardi and Lois M. Potter-Sanders, *Tortilla Flat Arizona Then and Now* (Tortilla Flat, AZ: Sunshower Press, 2006). In eastern Arizona, Safford's evolution

is chronicled in Graham County Historical Society, *1874-Safford-1974 Centennial* (Safford, AZ: Graham County Historical Society, 1974), and St. Johns' is detailed in Charles B. Wolf, *Sol Barth of St. Johns: The Story of an Arizona Pioneer* (N.p.: First Books Library, 2002). A useful overview of some of Sedona's recent growth is Historic Preservation Commission, City of Sedona, *Historic Resource Survey City of Sedona, Arizona* (2001).

Books on US 66 have multiplied over the years. Some of the best include Quinta Scott and Susan Croce Kelly, *Route 66: The Highway and Its People* (Norman: University of Oklahoma Press, 1988); Tom Snyder, *The Route 66 Traveler's Guide and Roadside Companion* (New York: St. Martin's Press, 1990); Arthur Krim, *Route 66: Iconography of the American Highway* (Santa Fe, NM: Center for American Places, 2005); and Michael Karl Witzel and Gyvel Young-Witzel, *Legendary Route 66: A Journey Through Time Along America's Mother Road* (St. Paul, MN: Voyageur Press, 2007). Wallace's own description of the road in the mid-1950s is found in "Arizona 66: The Scenic Wonderland Highway," *AZ* (May 1955). Holbrook's historical saga can be followed in Harold Wayte Jr., "A History of Holbrook and the Little Colorado Country"

(master's thesis, University of Arizona, 1962) and in Lyle Johnston, ed., *Centennial Memories, Holbrook, Arizona, 1881–1981* (Holbrook, AZ: Holbrook Public Library, 1993). Winslow's historical landscape is explored in Vada Carlson and Joe Rodriguez, *A Town is Born: A Pictorial Review of Winslow, Arizona, First Fifty Years* (Winslow, AZ: County Printers, 1981). Farther west, the entertaining *Images of America* series offers fine treatments on both Flagstaff and Ash Fork. See James E. Babbitt and John G. DeGraff III, *Flagstaff* (Charleston, SC: Arcadia Publishing, 2009) and Marshall Trimble, *Ash Fork* (Charleston, SC: Arcadia Publishing, 2008). Added detail on Peach Springs is offered in Roman Malach, *Peach Springs in Mohave County* (New York: Graphicopy, 1975).

Arizona's urban landscapes are included in some larger, regional studies of western American cities. See, for example, John Reps, *The Forgotten Frontier: Urban Planning in the American West Before 1890* (Columbia: University of Missouri Press, 1981) and Carl Abbott, *How Cities Won the West: Four Centuries of Urban Change in Western North America* (Albuquerque: University of New Mexico Press, 2008). On Phoenix and Tucson, see Patricia Gober, *Metropolitan Phoenix: Place Making and Community Building*

in the Desert (Philadelphia: University of Pennsylvania Press, 2005) and Michael F. Logan, *Desert Cities: The Environmental History of Phoenix and Tucson* (Pittsburgh, PA: University of Pittsburgh Press, 2006). On Mesa's Buckhorn Baths, explore Box 36 in the Lollesgard Postcard Collection, PC238, AHS. A nice example of urban booster rhetoric for Prescott is the Yavapai Commercial Club, "Yavapai County Arizona: The Treasure Vault of the Southwest" (Prescott, AZ: Yavapai Commercial Club, 1907). Tucson's storied Southern Pacific Depot is profiled in Roger Straus, Ed Breslin, and Hugh Van Dusen, *America's Great Railroad Stations* (New York: Viking Studio, 2011), 216–19. A fine local history of the Sabino Canyon area is David Lazaroff, *Sabino Canyon: The Life of a Southwestern Oasis* (Tucson: University of Arizona Press, 1993).

Arizona's far corners can be explored in a bit more depth. On Nogales and other border zones, see Daniel D. Arreola's delightful *Postcards from the Sonora Border: Visualizing Place Through a Popular Lens, 1900s–1950s* (Tucson: University of Arizona Press, 2017). The large federal role in western dam construction is effectively reviewed in Donald Worster, *Rivers of Empire: Water, Aridity, and the Growth of the American West* (New York: Oxford University

Press, 1985); Marc Reisner, *Cadillac Desert: The American West and Its Disappearing Water* (New York: Penguin Books, 1986); and David P. Billington, Donald C. Jackson, and Martin V. Melosi, *The History of Large Federal Dams: Planning, Design, and Construction* (Denver, CO: US Department of the Interior, Bureau of Reclamation, 2005). On the larger cultural iconography of Hoover Dam, dive into Anthony F. Arrigo, *Imaging Hoover Dam: The Making of a Cultural Icon* (Reno: University of Nevada Press, 2014). For a bit more background on the Bundy Family, see Tay Wiles, "Celebrity Scofflaw: How the feds helped make Cliven Bundy a celebrity," *High Country News* (April 30, 2018).

Page numbers in *italic* text indicate illustrations.

Adams, Ansel, 9
agriculture: along Virgin River, *160–61*; at Mission San Xavier del Bac, *48–49*; in Canyon de Chelly, *46–47*; in Salt River Valley, 11
Ajo, 61, *72–73*
Ancestral Puebloans, *44–45*
Apaches: in Chiricahuas, *38–39*
Apache Trail, *88–89*
Arizona: history of, 10–13; physical geography of, 11. *See also specific localities*
Arizona Central Railroad, 34
Arizona Highway Department: Wallace employed by, 5–8; motto of, 12
Arizona Highways (magazine): and coverage of US 66, 100; and opening of Hoover (Boulder) Dam, 42; tourism promotion by, 13; Wallace's contributions to, 8, 22
Arizona Land and Water Trust, *148–49*
Arizona State University, *127*

Arizona Strip, *56–57*, 141–42, *158–59*, *162–63*
Arizona Territory, 10–11, *162–63*
Ash Fork, *116–17*
Austin, Mary, 11
automobiles: impact of, in Arizona, 11–13. *See also* highways

Beale expedition, 4, *52–55*, *120–21*
Bisbee, 61, *76–77*, *146–47*
Boulder Dam. *See* Hoover Dam
bridges: at Cameron, *82–83*; at Marble Canyon, *154–55*; at Perkinsville, *34–35*
Buckhorn Baths, *128–29*
Bundy Family, 142, *158–59*

cameras: used by Wallace, 3; used by Wyckoff, 13, 15. *See also* photography
Cameron, *82–83*
Canyon de Chelly, 11, *46–47*
Casa Grande National Monument, *42–43*
Castle Rock, *36–37*
cattle. *See* livestock grazing

cemeteries: in Holbrook, *106–7*; in Quartzite, *54–55*
Chino Wash, *52–53*
Chiricahua Mountains, *38–39*
cities. *See* urbanization; *and specific cities*
Clark, William, 59, *70–71*
climate, 11. *See also* climate change
climate change, 23, *30–31*, *156–57*. *See also* tree invasion
Colorado River, 12, *156–57*
Commonwealth Mine, *62–63*
Congress Junction, 80, *84–85*
copper mining. *See* mining; *and specific localities*

dams: as symbols of progress, 12. *See also specific dams*
deserts: changing ideas about, 11
Dutton, Allen, 8

economy: of Arizona, 10–13. *See also* agriculture; mining; tourism; transportation; urbanization

environment: and change over time, 23; in Arizona, 11. *See also* climate; geology; mining; tree invasion; vegetation

ethnicity: patterns in Arizona, 10, 12. *See also specific groups*

farming. *See* agriculture

Flagstaff: and US 66, 101, *110–11*; and wildfire prevention, 29

Fly, Camillus, 9

Fort Defiance, *90–91*

Fort Lowell, 43

Frasher Fotos, 9

Gadsden Purchase, 10, 50

geology: and landforms in Arizona, 11; and mining, 59–61; in eastern Arizona, *32–33*; near Oatman, *64–65*; of Chiricahua Mountains, *38–39*; of Vermillion Cliffs, *26–27*

Gila Valley, Globe, and Northern Railroad, 92

Globe, 11, 60, *74–75*

Grand Canyon: and El Tovar Hotel, 11; visited by Wallace, 5, 8

Great Depression: in Arizona, 5

Grey, Zane, 11, 56–57, *152–53*

Harvey House, *116–17, 118–19*

Hassayampa Hotel, 125, *130–31*

Haynes, Willis, 9

highway construction: in Arizona, 5–8. *See also* Arizona Highway Department; highways; *and specific highways*

Highway Department. *See* Arizona Highway Department

highways: and federal numbering system, 99; and growth in Arizona, 12. *See also* Arizona Highway Department; highway construction; *and specific highways*

Hi Jolly Monument, *54–55*

Hillside, 81, *86–87*

Hispanic population: and landscape change, 42; at St. Johns, *94–95*; historical influences of, 48–51; in Arizona Territory, 10

Hohokam peoples, *42–43*

Holbrook, 100, *106–7*

Hoover Dam, 12, 42, *156–57*

Hualapai Nation, *118–19*

Indians. *See* Native peoples

international border: at Nogales, *142–43, 144–45*; near Castle Rock, *36–37*

Interstate 10, *135*

Interstate 15, *161*

Interstate 40, 101, *102–7, 114–15*

James, George Wharton, 11

Jerome, 61, *70–71*

Kingman, *150–51*

Klett, Mark, 9

Lake Mead, *156–57*

Latter-Day Saints (LDS): at Safford, *92–93*; at St. Johns, *94–95*; settlement in northern Arizona, 56–57. *See also* Arizona Strip

Little Colorado River, *24–25, 82–83*

Littlefield, *160–61*

livestock grazing, 11; along the Verde River, *34–35*; and vegetation change, 23; at Rain Valley Ranch, *148–49*; in eastern Arizona, 94; in Wolf Hole, *158–59*; near Chiricahuas, *38–39*; near Springerville, 33

lumbering: near Flagstaff, 29

Lupton, *104–5*

Marble Canyon Bridge, *154–55*

Mesa, 124, *128–29*

Mexico: Wallace's work in, 4. *See also* international borders

Miami (Arizona), 60, *66–67*

mining, 11, 12, 59–77. *See also specific localities*

mining towns, 59–77. *See also specific settlements*

Mission San Xavier del Bac, 16, *48–49*

modernization: and mining landscapes, 59–61; in Arizona, 10–13; Wallace's embrace of, 12. *See also* urbanization

Mogollon Rim, 11, 22

Montoso Summit, *30–31*

Mormons. *See* Latter-Day Saints (LDS)

"Mother Road." *See* US Highway 66

Muench, Josef, 9

national forests: in the Chiricahua Mountains, *38–39*; in the Santa Catalina Mountains, *138–39*

native peoples, 10; and arts and crafts, 81, 94; as photographed by Wallace, 10, 42; at trading posts, *82–83, 90–91, 102–3, 152–53. See also specific peoples*

Navahopi Highway, *24–25*

Navajo Bridge, *154–55*

Navajo Nation: at Cameron, *82–83*; at Canyon de Chelly, *46–47*; at Fort Defiance, *90–91*; at Tuba City, *152–53*; described along US 66, *100–101*; near Lupton, *104–5*

New Deal, 48, 123

Nichols, Tad, 9

Nogales, 142–43, *144–45*

Oak Creek Canyon, 5, 8, *96–97*

Oatman, *64–65*, 101

Painted Desert, 5, 42, 100

Peach Springs, 6, *118–19*

Pearce, *62–63*

Peña Blanca Spring, *36–37*

Perkinsville, *34–35*

Phelps Dodge Corporation, 59, 70–73

Phoenix: along Central Avenue, *126–27*; as health resort, 11; as home to Wallace, 11–12; growth of, 11–12, 123–25

photography. *See* cameras; repeat photography; *and specific photographers*

Pipe Spring National Monument, *56–57*

population: change in Arizona, 10–13

Precisionism, 165

Prescott, 123–25, *130–31*

public lands: and the Bundy family, 142. *See also* Hoover Dam; national forests; *and specific localities*

Quartzite, *54–55*

railroads: as surveyed by Wallace, 4; in Arizona, 10–11. *See also specific railroads*

Rain Valley Ranch, *148–49*

ranching. *See* livestock grazing

recreation. *See* national forests; tourism

repeat photography; definitions of, 1; doing, 2, 15–16; in Montana, 14. *See also* photography

rephotography. *See* repeat photography

Roosevelt Dam, 11, *88–89*

Rothrock, George, 9

Ruby, *60–61, 68–69*

Russian olive: as invasive, 47

Sabino Canyon, 124, *138–39*

Safford, 80, *92–93*

St. Johns, 80–81, *94–95*

Salt River Canyon, 7

San Francisco Peaks, 5, 11, *28–29*, 100; as seen along US 66, *112–13*

San José de Tumacácori Mission. *See* Tumacácori National Monument

Santa Catalina Mountains, *134–35, 138–39*

Santa Fe Railroad, 10; along route of Beale expedition, *52–53*; near Ash Fork, *116–17*; station at Flagstaff, 101, *110–11*

Santa Rita Mountains, *50–51*

San Xavier del Bac. *See* Mission San Xavier del Bac

San Xavier Indian Reservation, *48–49*

Schultz Pass, *28–29*

Sedona, 81, *96–97*

Seligman, *52–53*, 100

Sitgreaves Pass, 101, *120–21*

Southern Pacific Railroad, 10–11; in Tucson, 125, *132–33, 136–37*

Springerville: landscapes of, 18, *32–33*

State Highway Department. *See* Arizona Highway Department

suburbs, 12–13, 124; in Mesa, 128–29; near Tucson, 48–49, 138–39. *See also* urbanization

Superior, *1*

tamarisk, *161*

Tohono O'odham Nation, 10, *48–49*

Tom Reed Mine, 61, *64–65*

Tortilla Flat, *88–89*

tourism, 8, 11; and growth of Sedona, *96–97*; and hot springs, *128–29*; at Tortilla Flat, *88–89*; at trading posts, *82–83*; in mining towns, 61, *70–71, 76–77*; on Verde River, 35. *See also specific localities*

towns, 71–97. *See also* urbanization; *and specific localities*

transportation: evolution of, in Arizona, 10–13. *See also* highways; railroads

tree invasion, 23; in central Arizona, *34–35*; in eastern Arizona, *30–31, 46–47, 90–91, 104–5*; near Flagstaff, *29*; of mesquite in southern Arizona, *36–37, 68–69, 88–89, 146–49*

Tuba City, *152–53*

Tucson: as health resort, 11; depot in, *132–33*; growth of, 123–25, *134–37*; history of, 10–12; suburban expansion of, *138–39*

Tumacácori National Monument, 42, *50–51*

US Highway 60, 7; east of Show Low, *30–31*

US Highway 66, 6, 10, 16, 18, 98–121. *See also specific localities along route*

US Highway 70, 12, *92–93*

US Highway 80, *128–29, 146–47*

US Highway 89, 26, *82–83*

US Highway 91, *160–61*

US Highway 93, *150–51, 156–57*

University of Arizona, *134–35*

urbanization, 10–13, 123–39; and mining, 59–77. *See also specific localities*

Utah: border with Arizona, *162–63*

Van Campen, Darwin, 9

Van Dyke, John, 11

vegetation: change with elevation, 22; patterns in Arizona, 11; planting of, in Canyon de Chelly, *46–47*. *See also* tree invasion

Verde Canyon Railroad, 35

Verde River, *22–23, 34–35*

Vermillion Cliffs, *26–27, 154–55*

Virgin River, *160–61*

Wallace, Henrietta, 2, 6, 8, 10

Wallace, Norman: cameras used by, 3; landscapes photographed by, 8–10; life of, 2–10, 16, 165–66; photo log books of, 3–4, 9–10, 14, 22

Weston, Edward, 9

White Mountains, 11

Williams: and US 66, *112–15*

Winslow, 100, *108–9*

Winsor Castle, *56–57*

Wolf Hole, 141–42, *158–59*

Woodchute Mountain, 23, *34–35*

Wukoki Pueblo, *44–45*

Wupatki National Monument, 5, 43, *44–45*

Yarnell Hill, *14, 15*